ANDY WARHOL
HEADSHOTS
DRAWINGS
AND
PAINTINGS
ESSAY BY
BOB COLACELLO
JABLONKA GALERIE

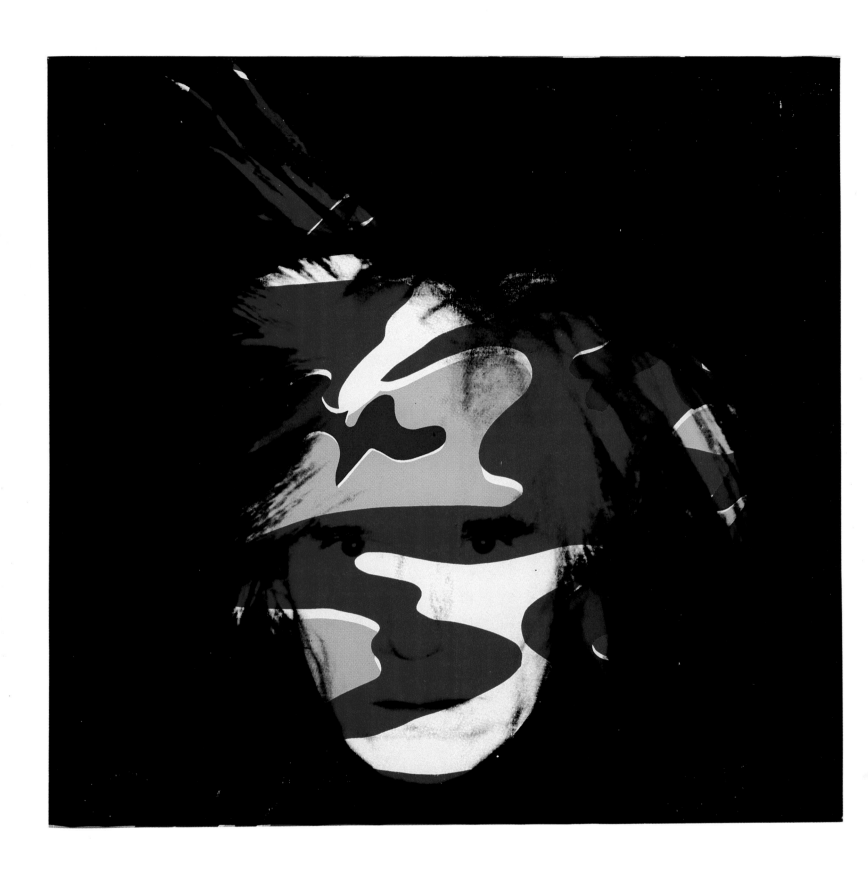

1 SELF-PORTRAIT 1986

ANDY WARHOL'S PORTRAITS
A Personal View

By Bob Colacello

When I started working at the Factory, as managing editor and art director of Interview magazine, in 1970, Andy Warhol was already telling reporters that he was "just a travelling society portrait painter." He was also doing his best to turn his entire staff into travelling society portrait salesmen. He did this by keeping salaries so low that the only way those of us who did not have rich parents could afford to live comfortably was to sell his art for a twenty percent commission. He was constantly urging us to seek out potential portrait clients, whom we jokingly called "victims." Rich kids who worked at the Factory — Brigid Berlin, Catherine Guinness, Averil Payson Meyer, Nenna Eberstadt — were urged to turn their parents into victims. "When's your mother going to have her portrait done?", he'd nag. "She can afford it, can't she?" Whenever one of us went to a dinner party at a rich person's house, Andy would ask, "Did you pop the question?"

During the twelve years I worked at the Factory, Andy must have painted close to a thousand portraits of socialites, tycoons, politicians, artists, art dealers, fashion designers, athletes, rock stars and anyone else who was willing to pay US$ 25.000 for a 40-inch-square silkscreen-and-acrylic-on-canvas picture of themselves. Most of the New York art world, which during the 1970s was infatuated with Conceptual Art and leftwing causes, reacted to Andy's commissioned portrait work with outrage and jealousy, calling it embarrassing, reactionary, frivolous and commercial beyond critical redemption. Andy didn't care, because the commissioned portrait business was supporting his more experimental film, video and publishing projects. And he approached the portraits like he did everything else — with diligence, creativity, and a fair amount of greed.

One was never enough. Clients were encouraged to commission additional panels, at US$ 15.000 each, of the same portrait in different colors, and those who didn't were considered "cheap." We were all trained to tell clients, "Repetition is a very important element of Andy's aesthetic." Of course, it really was, and the more serious collectors usually did order four or more panels. I think the champion was Colorado businessman John Powers, who had Andy do twenty-four panels of his Japanese wife Kimiko in a kimono.

Andy and I spent a year chasing after Imelda Marcos, hoping that she would order hundreds of portraits of herself for every government office in the Philippines, thus fulfilling one of Andy's fondest fantasies: the single commission that miraculously multiplied ad infinitum. We never got Imelda. But in 1976, Empress Farah Diba ordered eight portraits for her palace in Tehran, two more for the headquarters of Iran Air and the National Bank of Iran, and another two for the Iranian embassies in New York and Washington. The Shah liked her's so much that he commissioned three portraits of his own, but he was overthrown before they could be delivered.

Andy did his first commissioned portrait in 1963, of Ethel Scull, the wife of the New York taxicab tycoon and Pop Art collector Robert Scull. Titled "Ethel Scull 36 Times," it was based on photostrips taken in a photobooth in a five-and-dime store. But it wasn't until 1967, when he hired Fred Hughes, a stylish and socially ambitious young Texan, as his manager, that commissioned portraits became a significant part of Andy's artistic output and that he began to paint important Establishment figures. Fred's first move was to persuade his mentors, Dominique and Jean deMenil, the highly influential Houston collectors, to have Andy paint their private curator, Germaine McConaghty. It was particularly clever of Fred not to push the self-effacing, nun-like Dominique into having her own portrait done first. She soon fell in line; Andy did four portraits of Dominique deMenil in four shades of her favorite color — grey. Then came architect Philip Johnson, who had designed the deMenil house in Houston, and Jan Cowles, the wife of the publisher of Look magazine, Gardiner Cowles. The Cowleses were close friends of New York Governor Nelson Rockefeller and his second wife Happy, both of whom had portraits done by Andy in 1968. Fred also authorized Bruno Bischofberger, a Zurich dealer who had a chalet in St. Moritz, to sell portraits in Europe, and by 1974, Andy had received commissions from most of the jet set elite, including Gianni and Marella Agnelli, Stavros Niarchos, Baron Heini von Thyssen, Eric de Rothschild, São Schlumberger, Helene Rochas, Yves Saint Laurent, Valentino and Princess Diane von Furstenberg.

Almost all of Andy's portraits began with a Polaroid, and he often took ten or twelve packs of film to get a shot that both he and the client liked. The Polaroid would be blown-up into a negative, which Andy used to trace the subject's features on to the canvas. He would then color in the hair, skin, eyes, lips and background with acrylic paint. The negative was then converted into a silkscreen, which was used to print the photographic image in ink over the painted canvas. If the client was elderly or overweight, both of which were often

the case, Andy would perform "plastic surgery" on the negative before sending it out to be made into a silkscreen. He would literally scissor out bags under eyes, double chins, jowls, pimples and wrinkles. Andy's earliest portraits were almost minimalist in style, photographs silkscreened on a solid painted ground. But the European clients he did in the early 70s seemed to bring out the latent abstract expressionist in him. (The portrait of Parisian man-about-town Andre Morgue in this catalogue is typical of the period.) "Should I do a little de Kooning," he would say, as he slathered brightly colored swirls and zigzags of acrylic around the subject's head. "They'll like it, right? They're French. They'll think it's more intellectual."

When we moved from 33 Union Square West to a much larger space at 860 Broadway in 1975, Andy's portraits took on a new look: softer, less busy, with fewer painterly touches. And everyone — Mick Jagger, Willy Brandt, Roy Lichtenstein, Golda Meir — got a generous slash of azure, mint or lavender eye shadow across their upper lids. (See the portraits of Princess Ashraf of Iran and New Orleans Coca Cola heiress Tina Freeman in this catalogue.) As the 70s turned into the 80s, and fashion and society became increasingly enamored of glitter and glitz, Andy's portraits became shinier and harder. (See Carolina Herrera and Cindy Pritzker.) When women came to the Factory to have Andy take their Polaroids, they now were asked to remove their tops and to wrap a piece of fabric from Pierre Deux around their chest, leaving the shoulders bare. They were then made-up by Gig Williams, a professional stylist who was married to Andy's art assistant Ronnie Cutrone. She covered their faces, necks and shoulders in an even white base, erasing all imperfections — and saving Andy some plastic surgery work.

History seems to have a knack for turning the conventional wisdom of any given era on its head: Andy Warhol is now hailed for having a revived a dead art form, paving the way for such currently celebrated portraitists as Chuck Close and Alex Katz. But I've always believed that despite his funny remarks and nonchalant attitude, Andy was as serious about his commissioned portraits as he was about all of his work. He also knew exactly what he was doing. One day I asked him why he never would change the size of his portraits to accommodate clients' requests, when he was willing to listen to their suggestions regarding poses and colors. "They all have to be the same size," he said, "So they'll all fit together and make one big painting called 'Portrait of Society.' That's a good idea, isn't it? Maybe the Metropolitan Museum would want it someday."

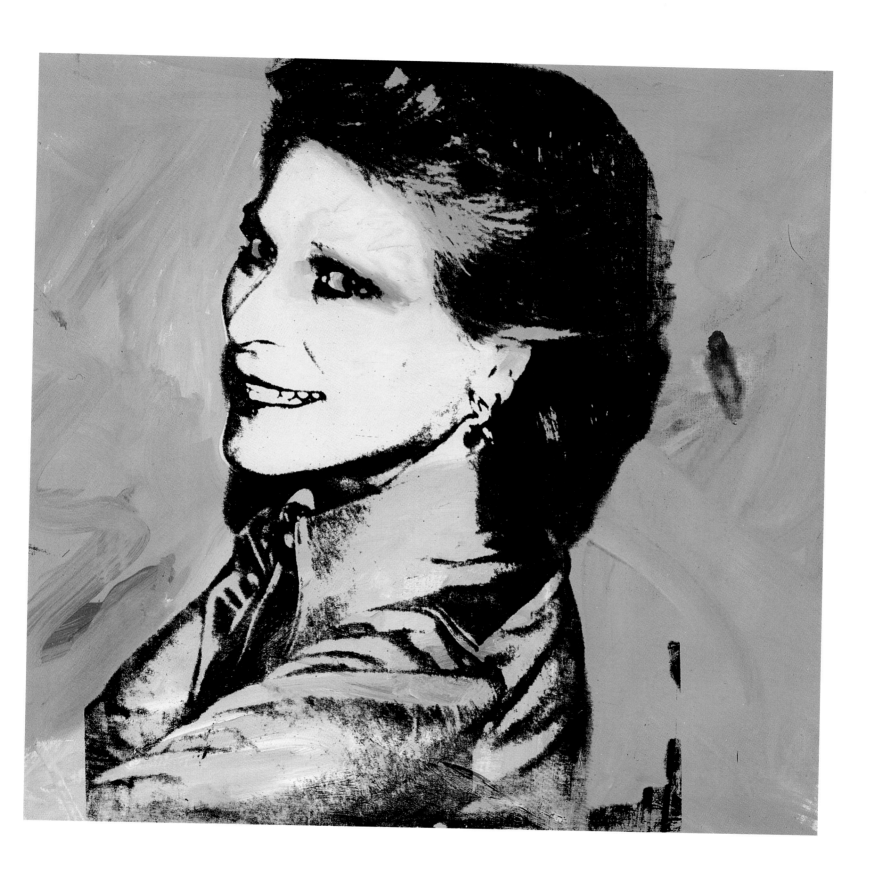

2 NAN KEMPNER 1972

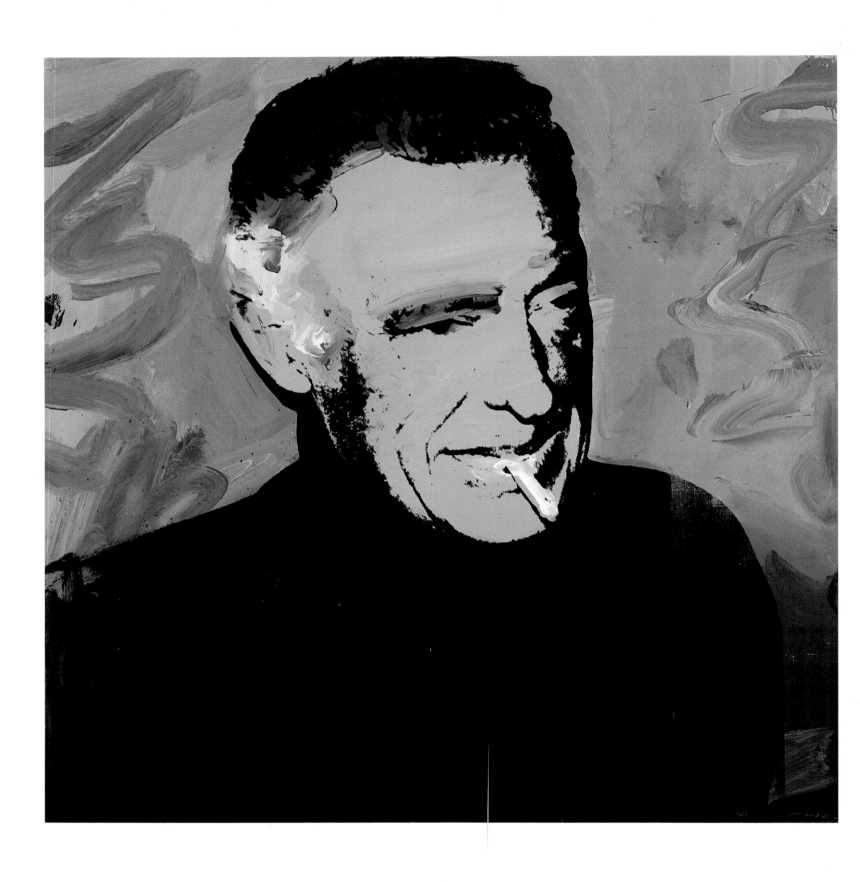

3 GIANNI AGNELLI 1972

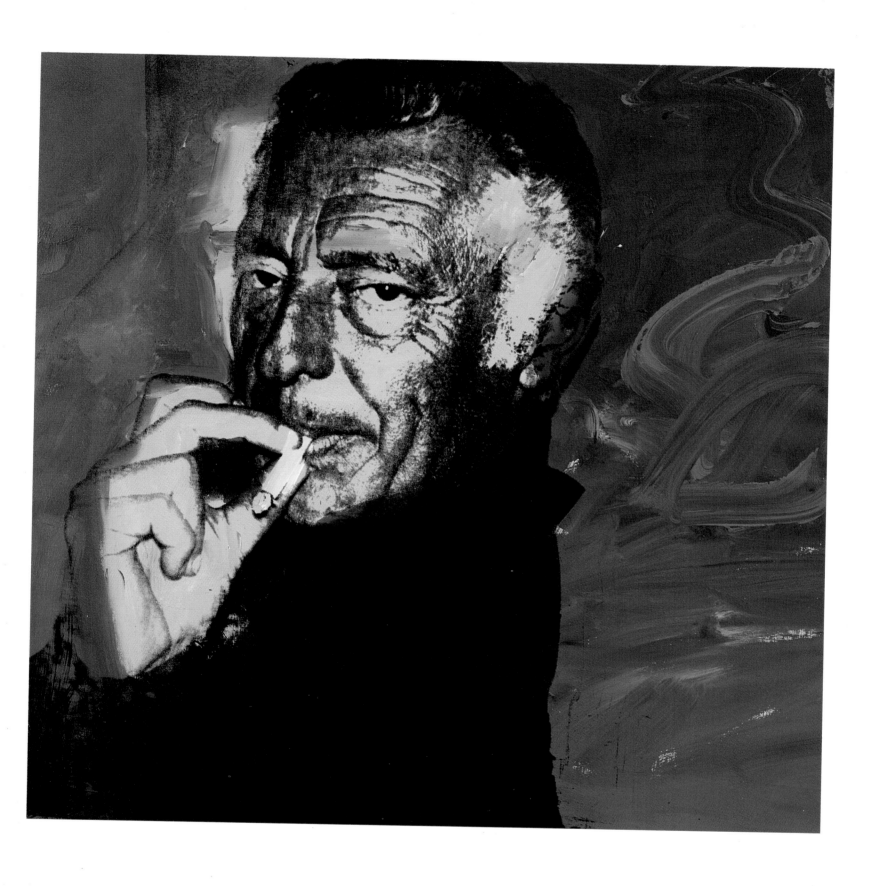

4 GIANNI AGNELLI 1972

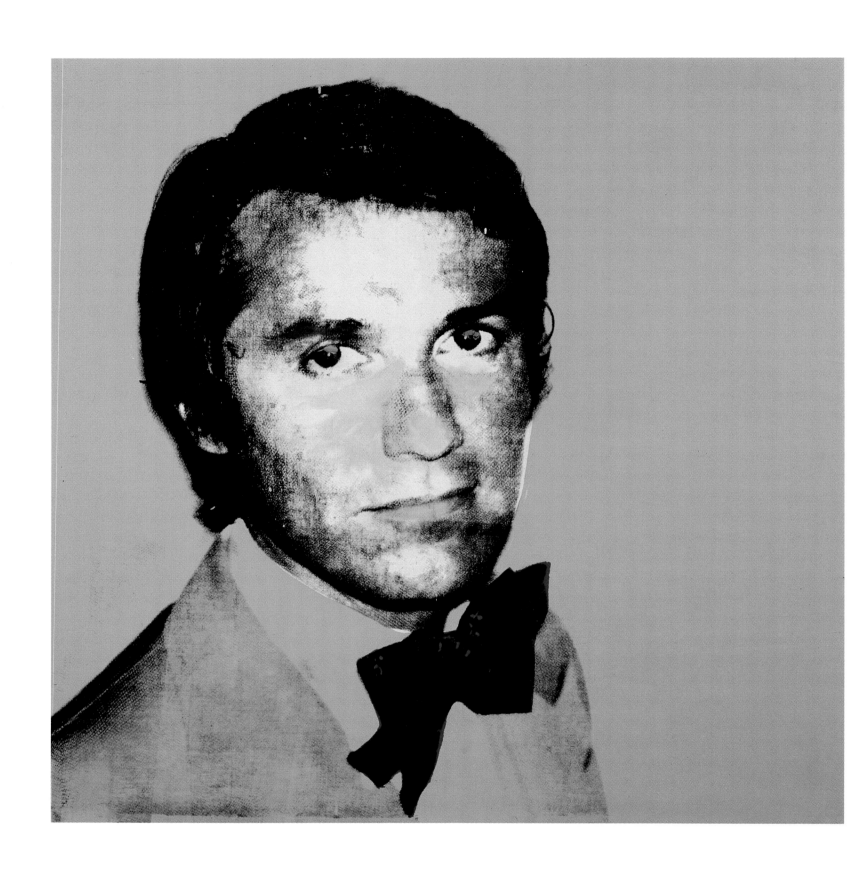

5 ANDRE MORGUE c.1972

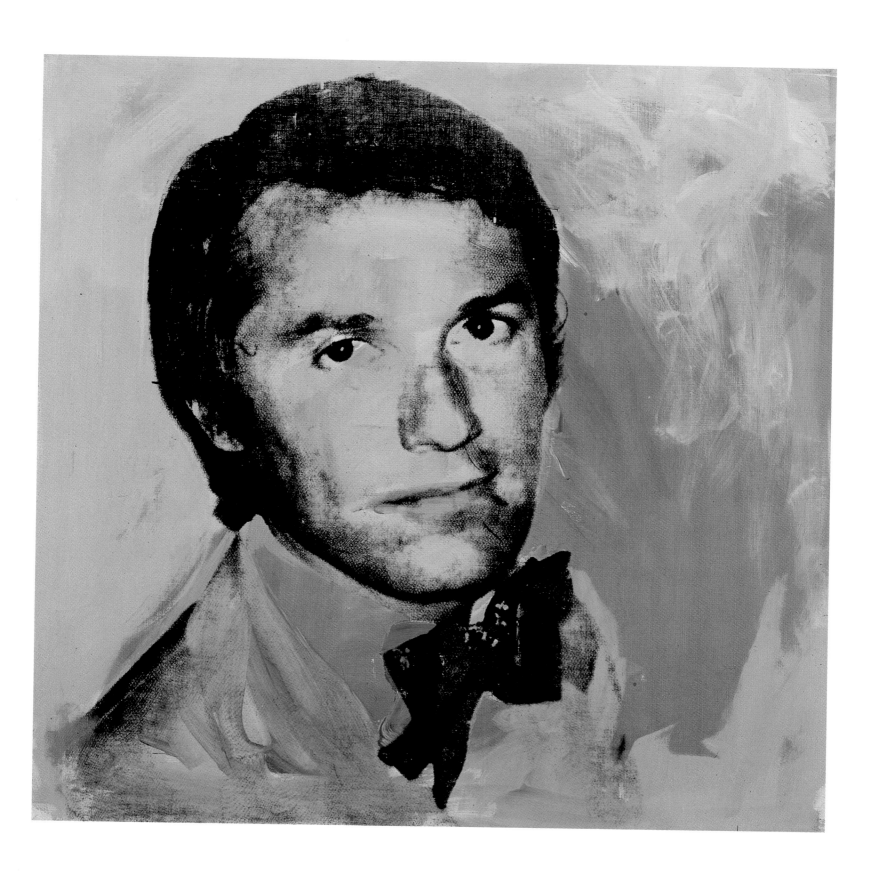

6 ANDRE MORGUE c.1972

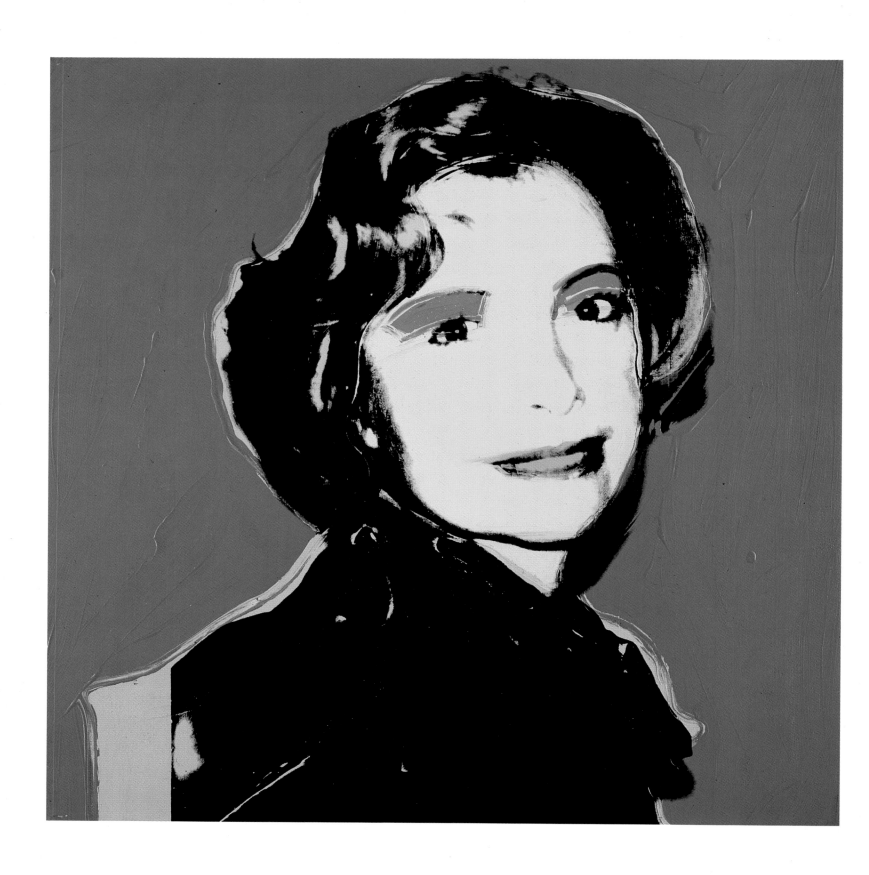

7 ZIMET, MRS. 1975

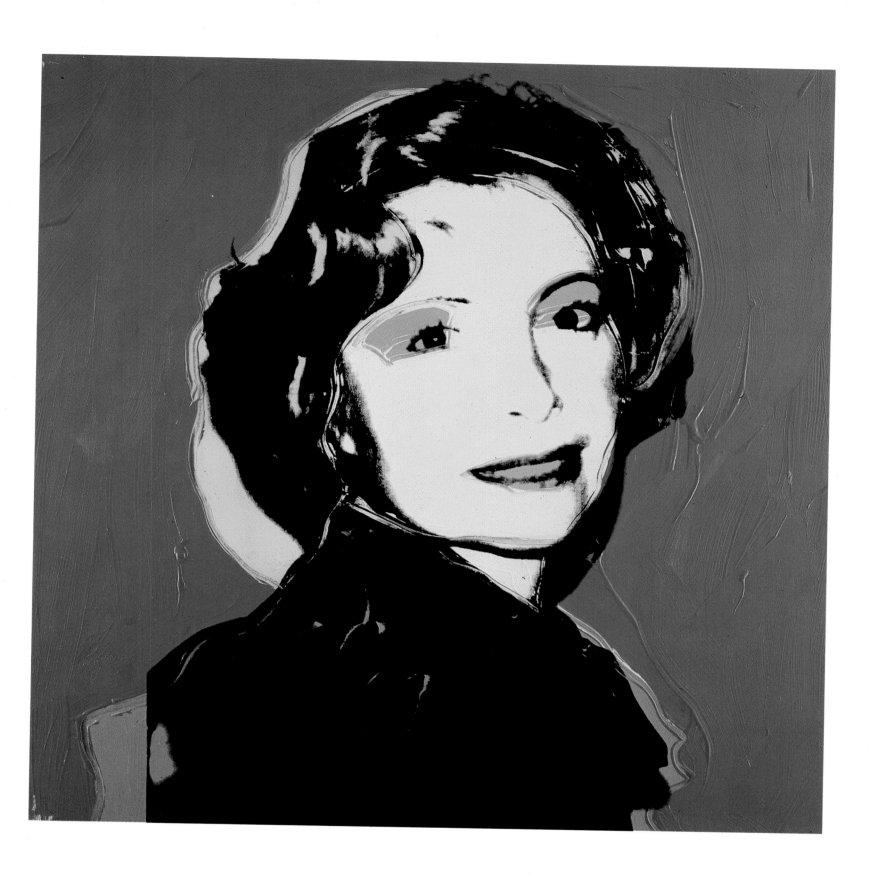

8 ZIMET, MRS. 1975

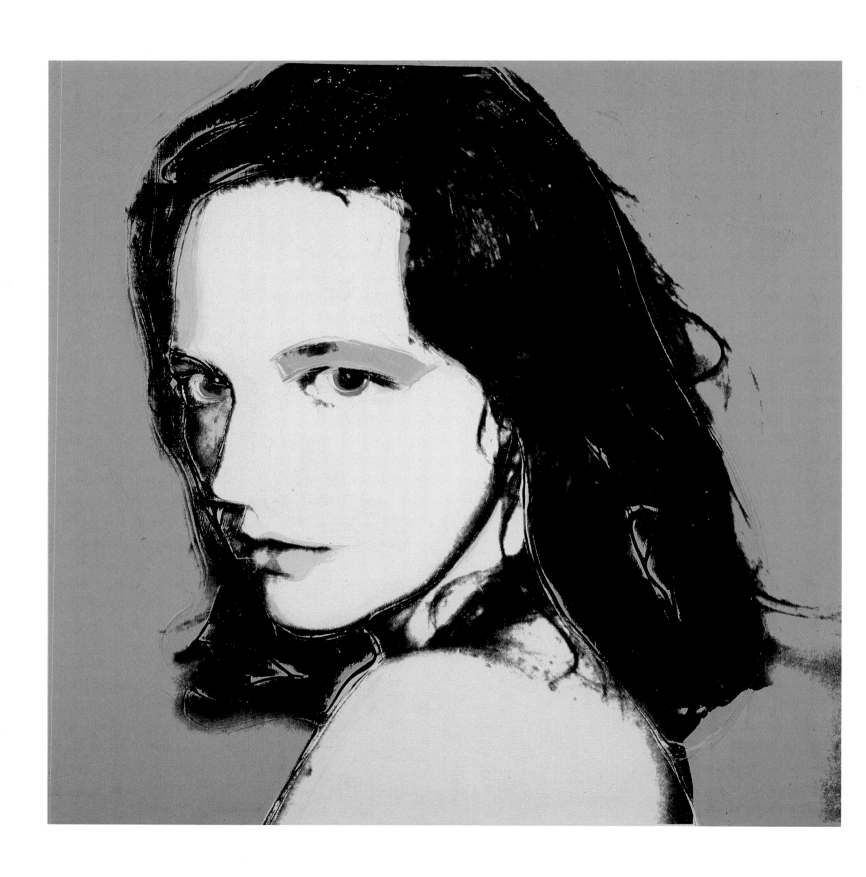

9 TINA FREEMAN 1975

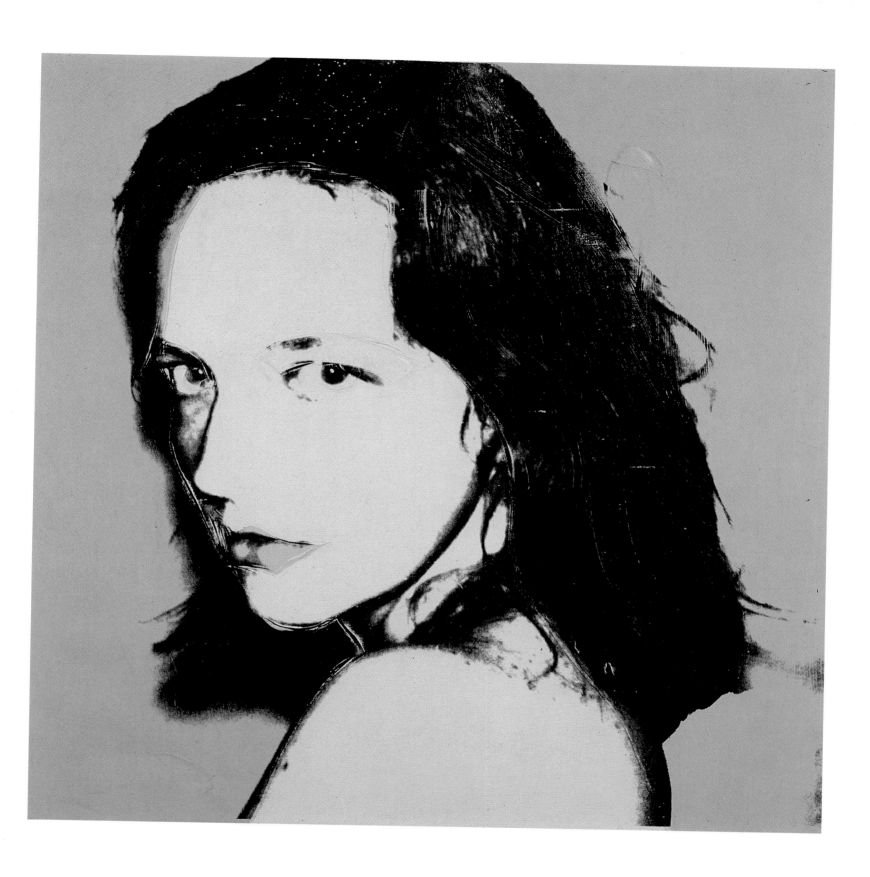

10 TINA FREEMAN 1975

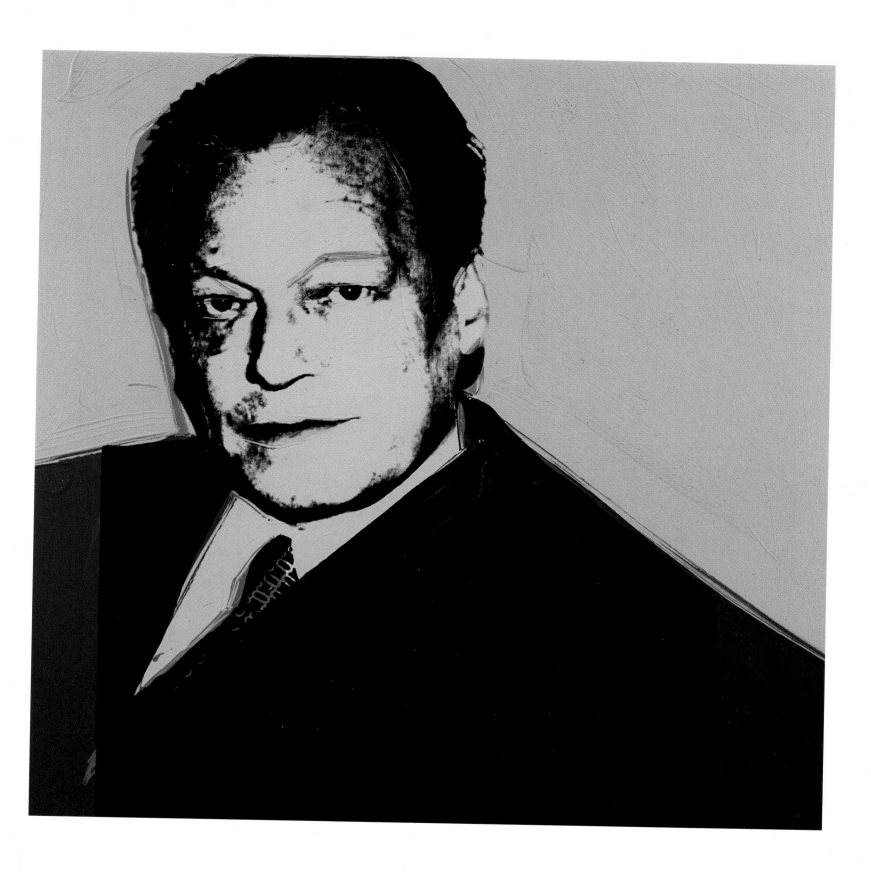

11 WILLY BRANDT 1976

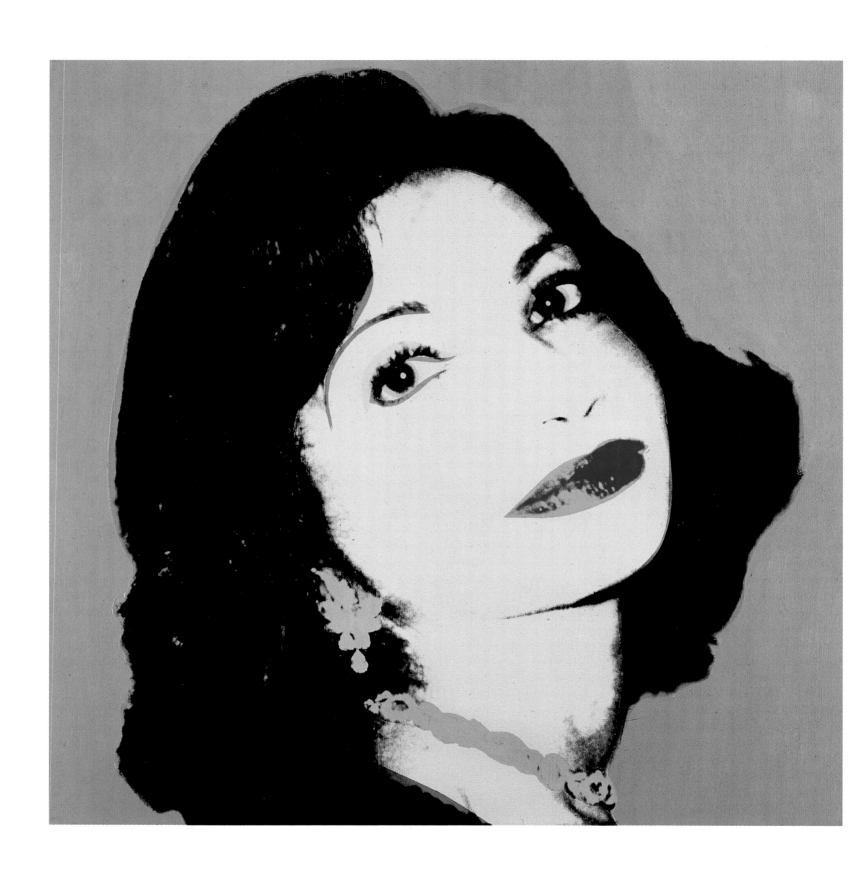

12 PRINCESS ASHRAF PAHLEVI (OF IRAN) 1977

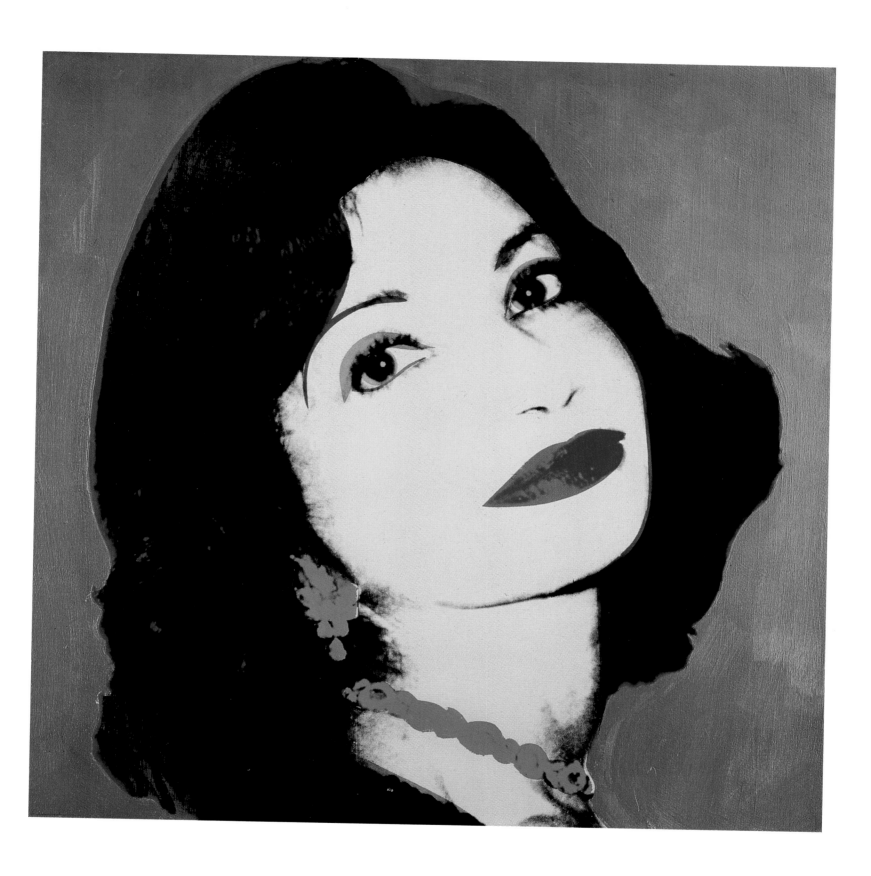

13 PRINCESS ASHRAF PAHLEVI (OF IRAN) 1977

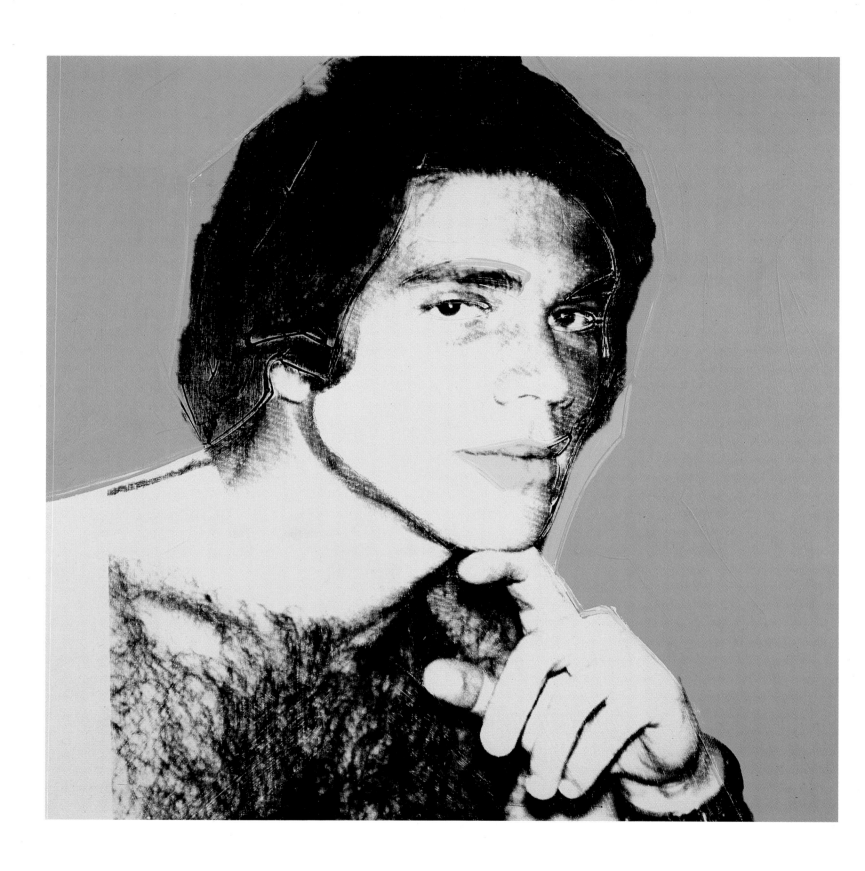

14 MARK LIEBOWITZ 1977

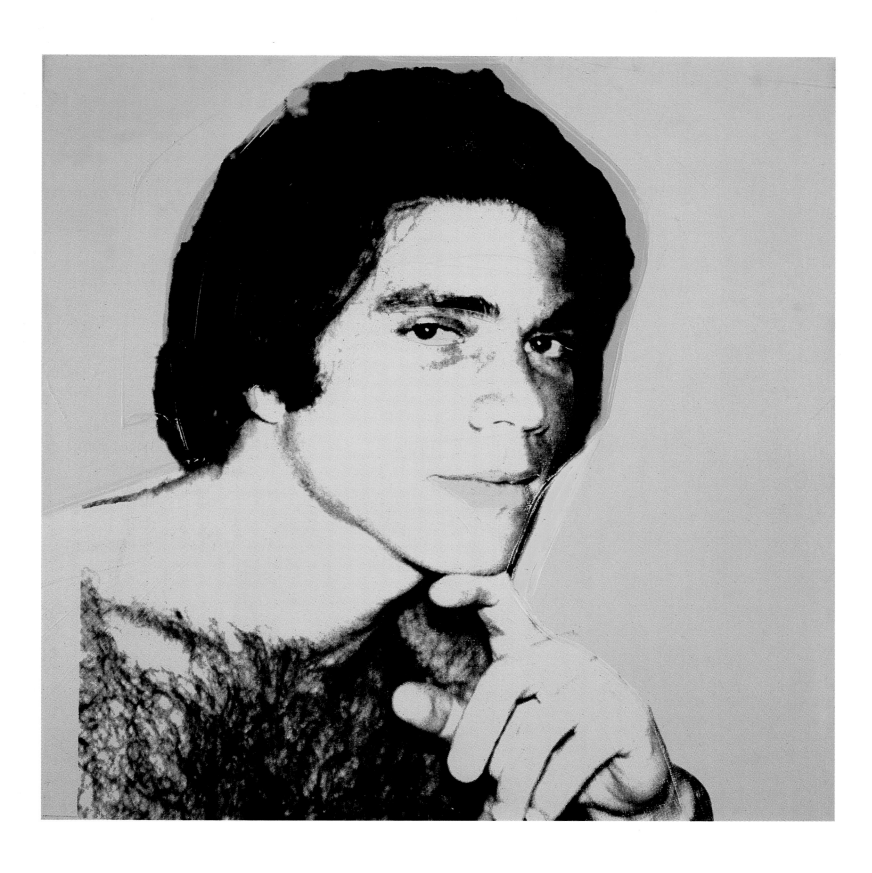

15 MARK LIEBOWITZ 1977

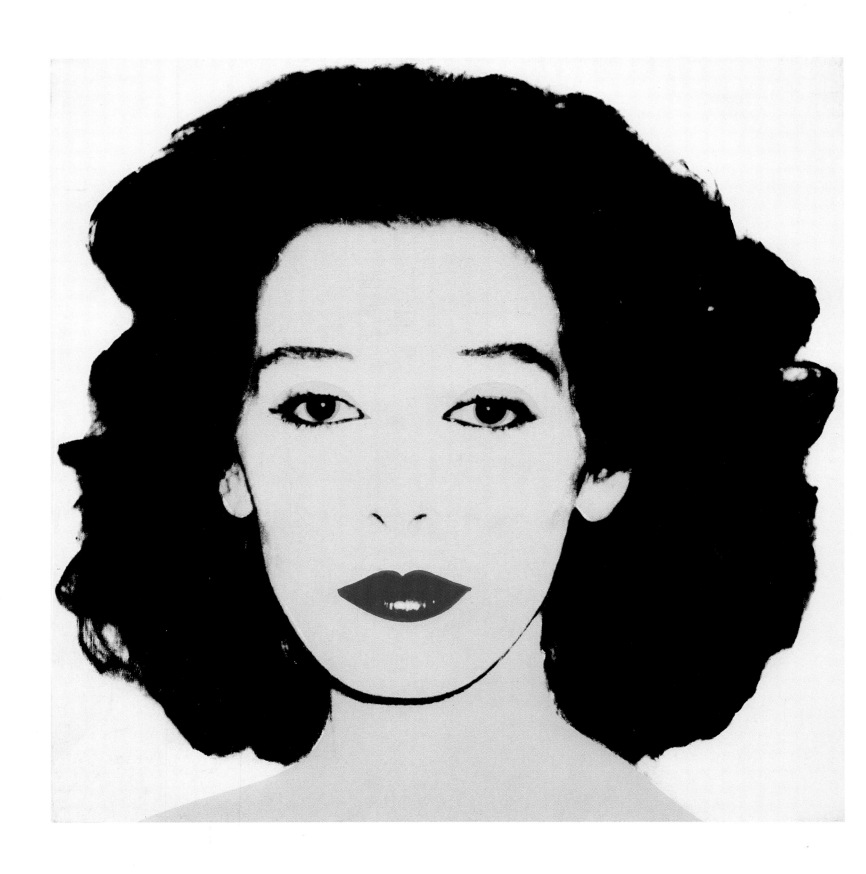

16 GALE SMITH 1978

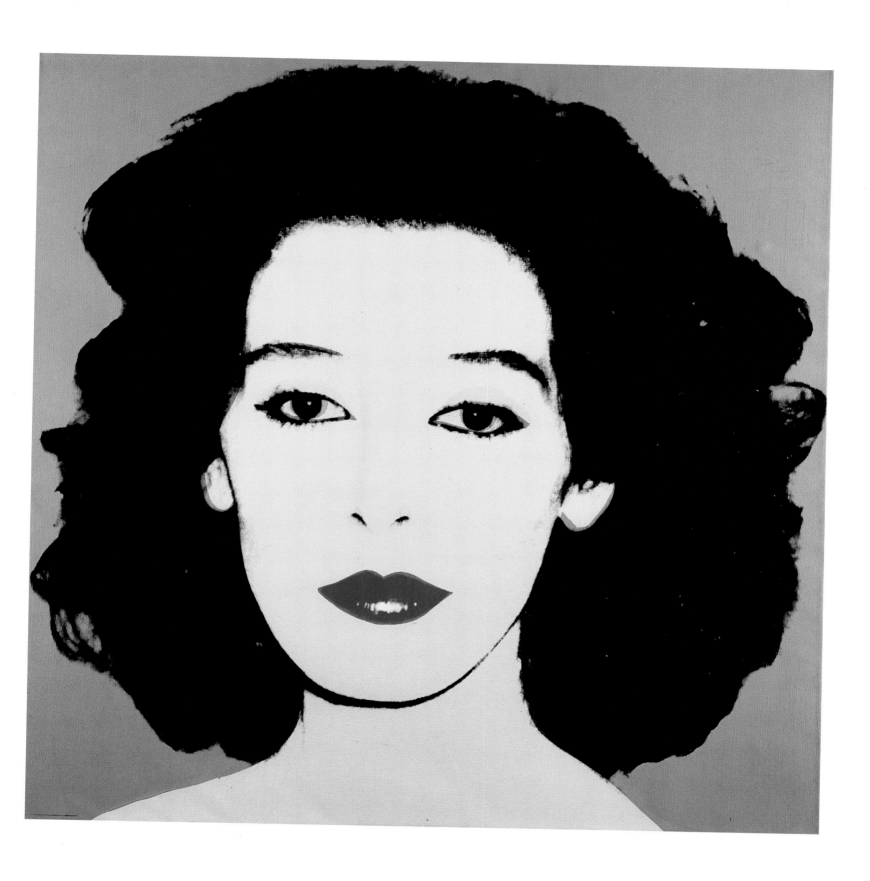

17 GALE SMITH 1978

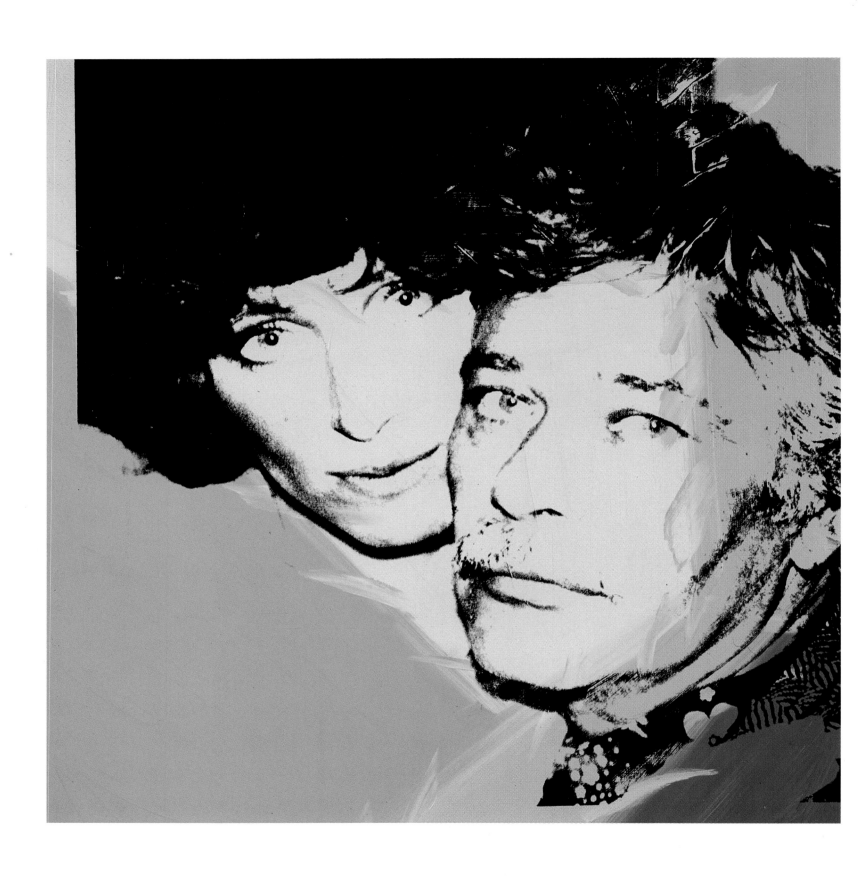

18 CHAMBERLAIN, MR. & MRS. c.1978

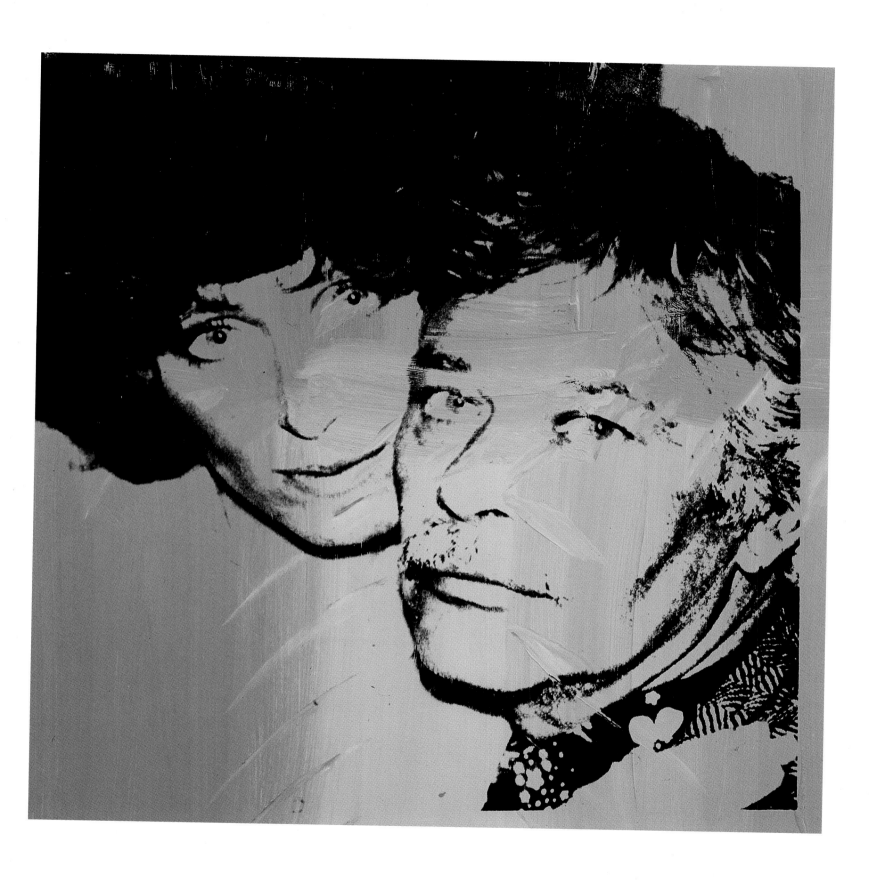

19 CHAMBERLAIN, MR. & MRS. c.1978

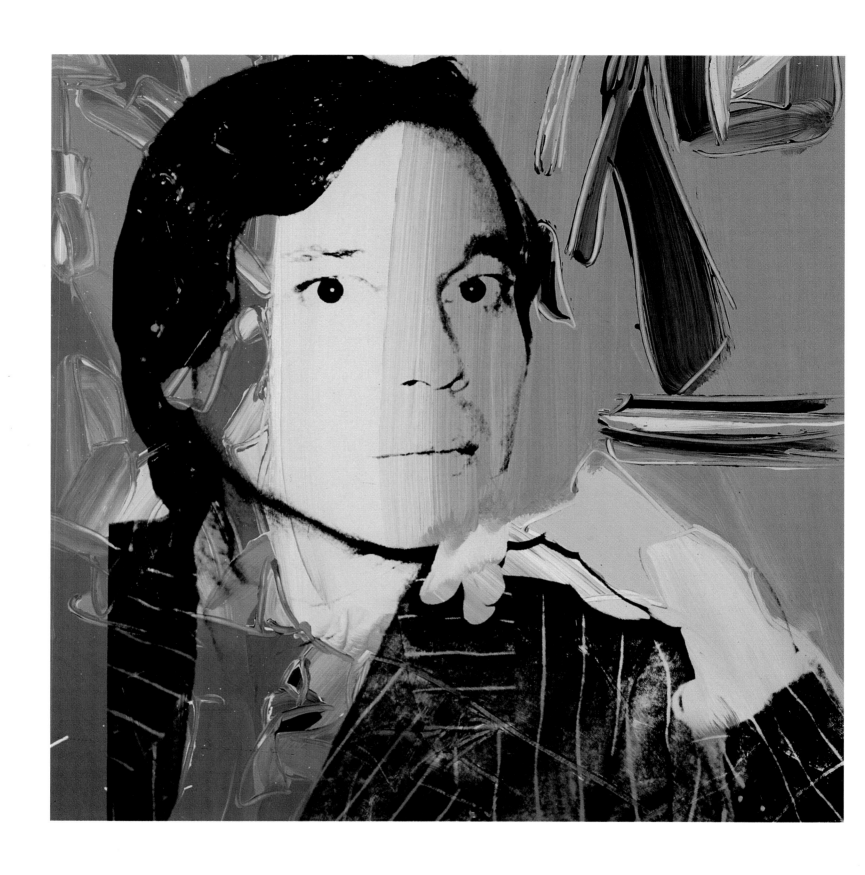

20 JOHN REINHOLD 1979

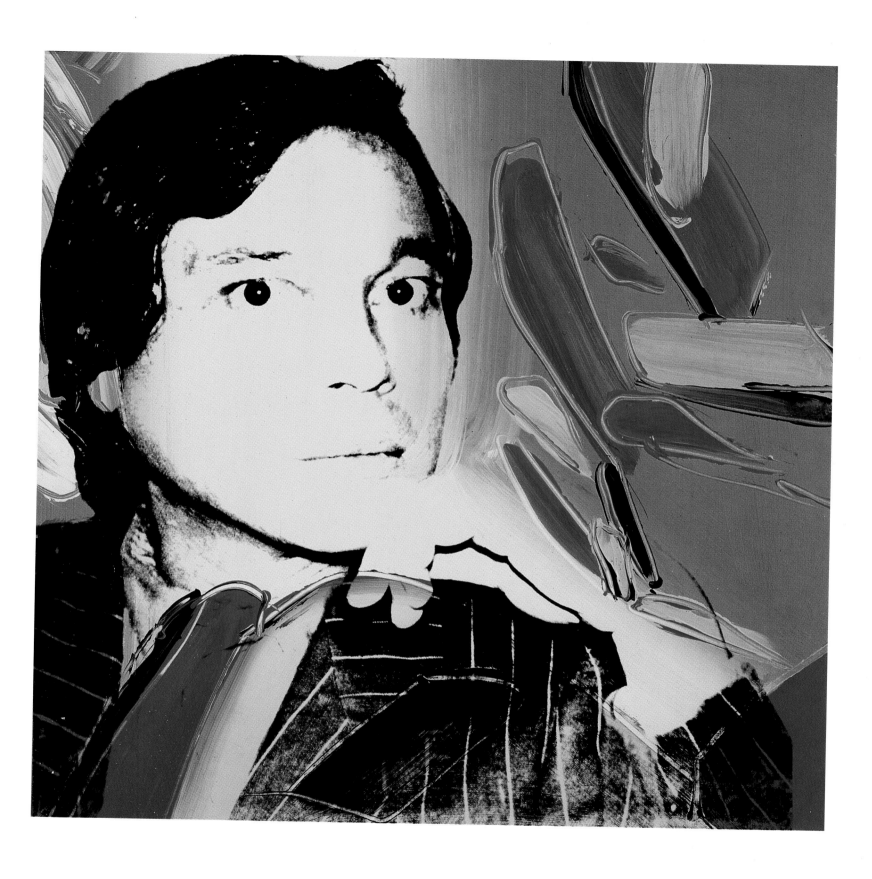

21 JOHN REINHOLD 1979

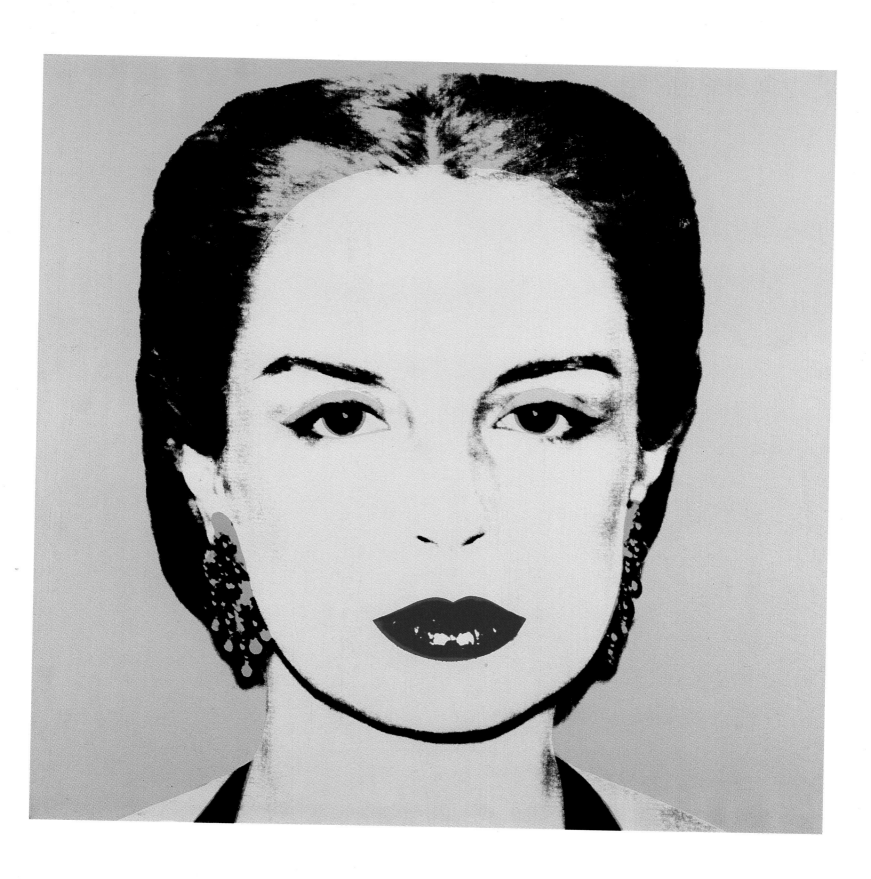

22 CAROLINA HERRERA 1979

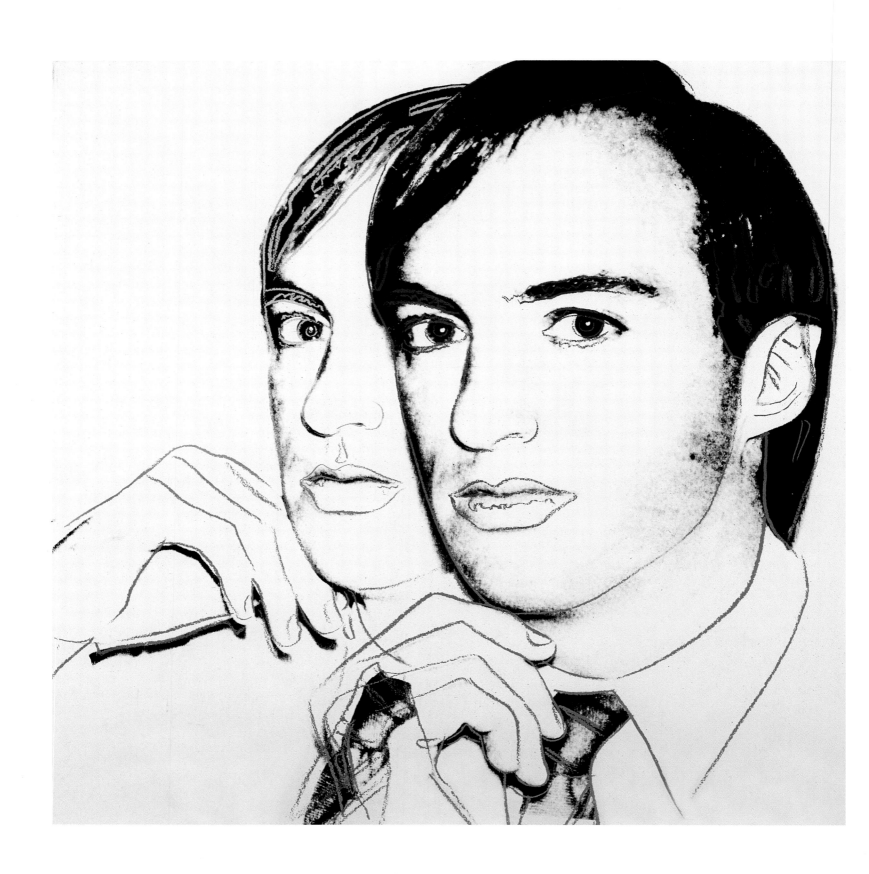

23 JON GOULD 1981

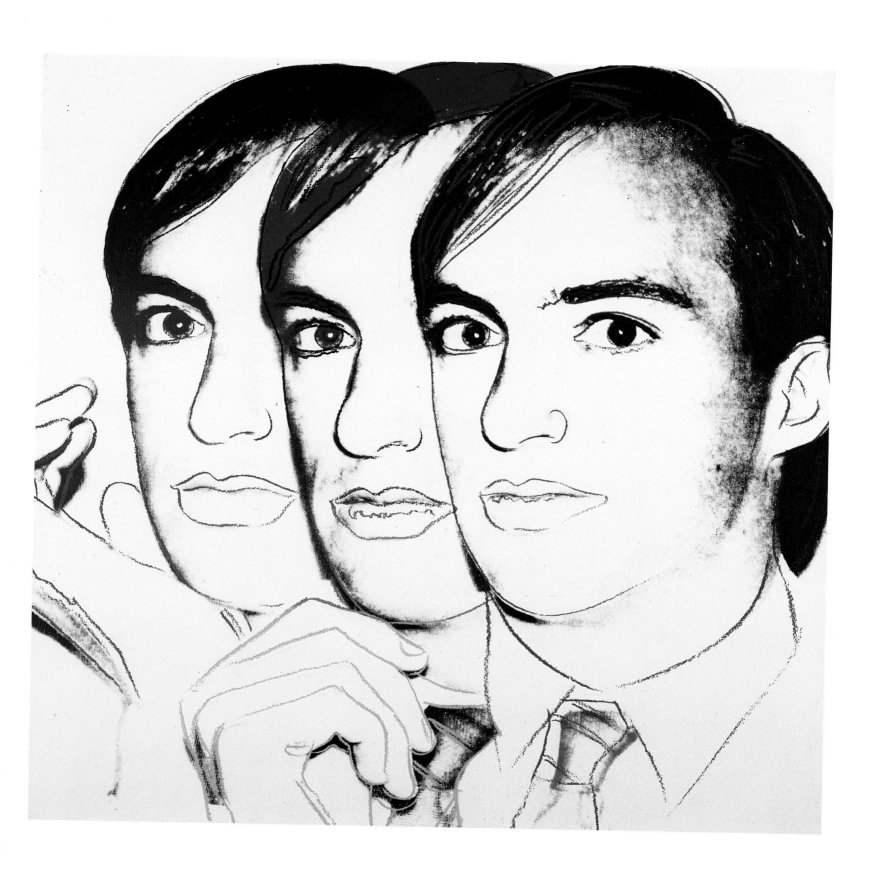

24 JON GOULD 1981

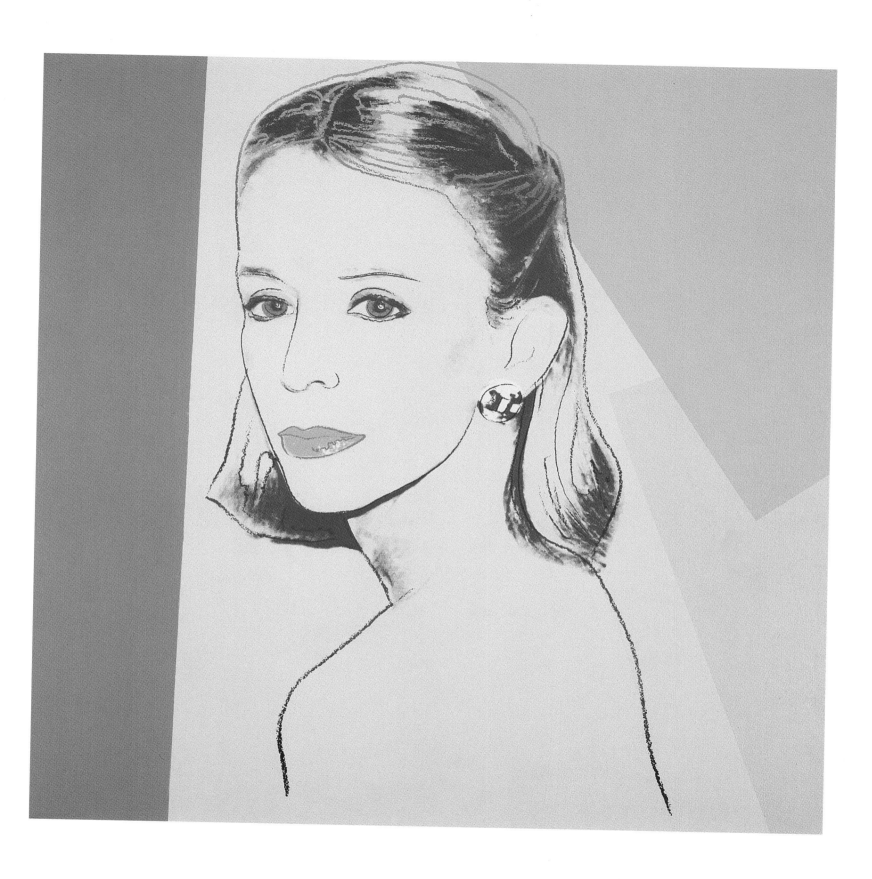

25 ANNE BASS 1981

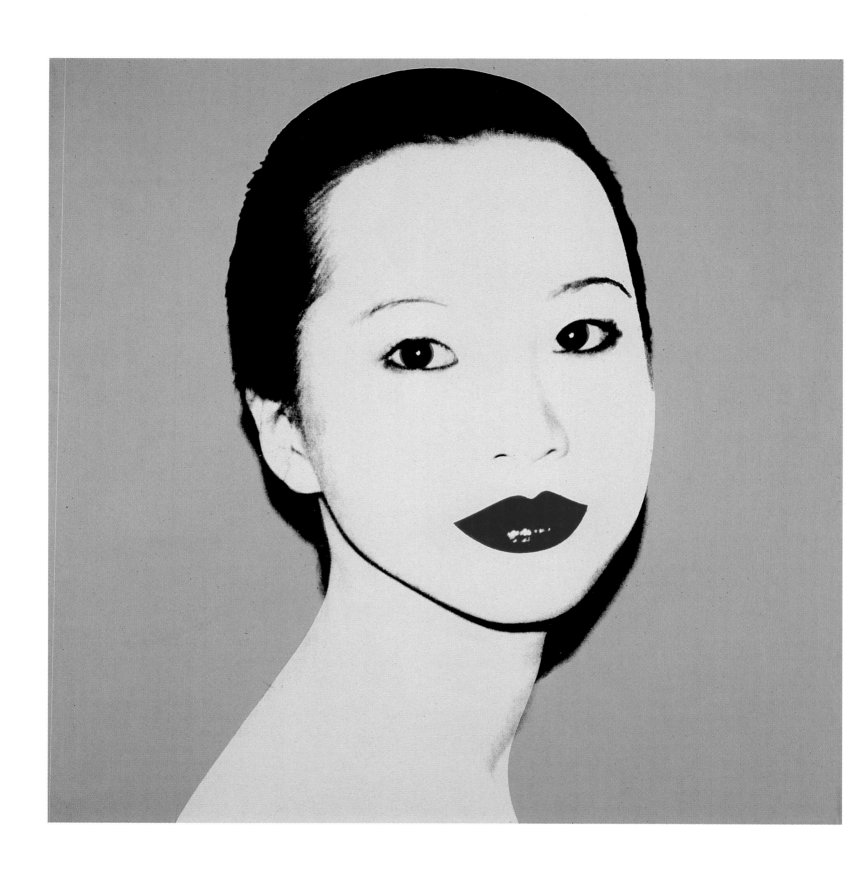

26 JULIANNA SIU 1982

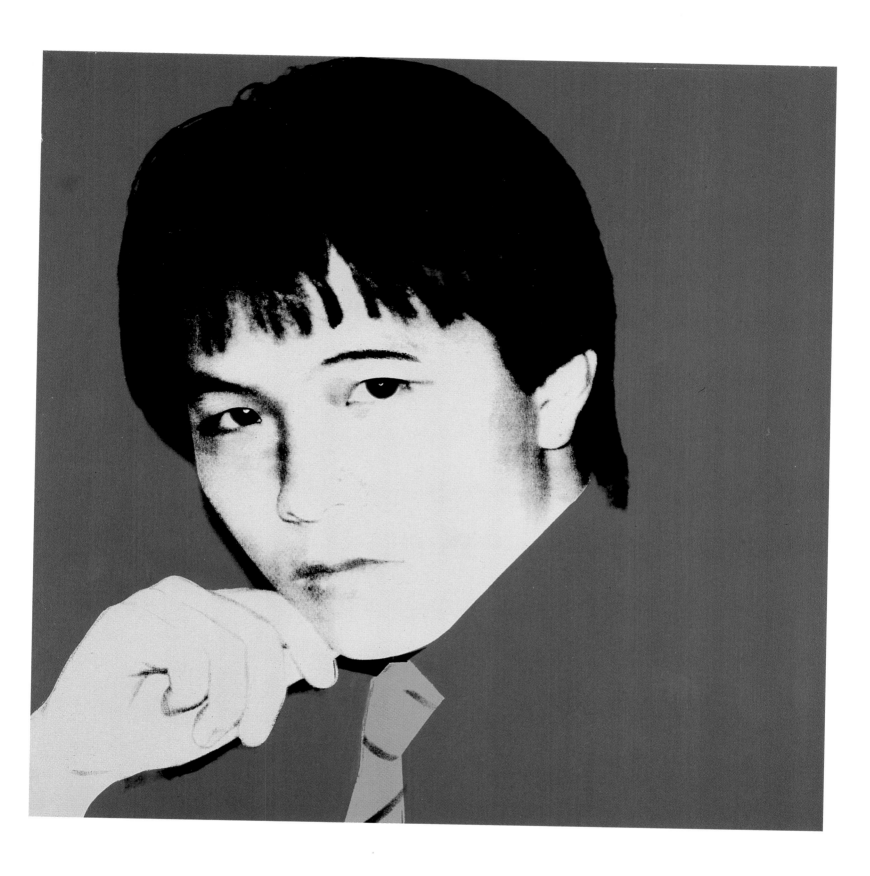

27 ALFRED SIU 1982

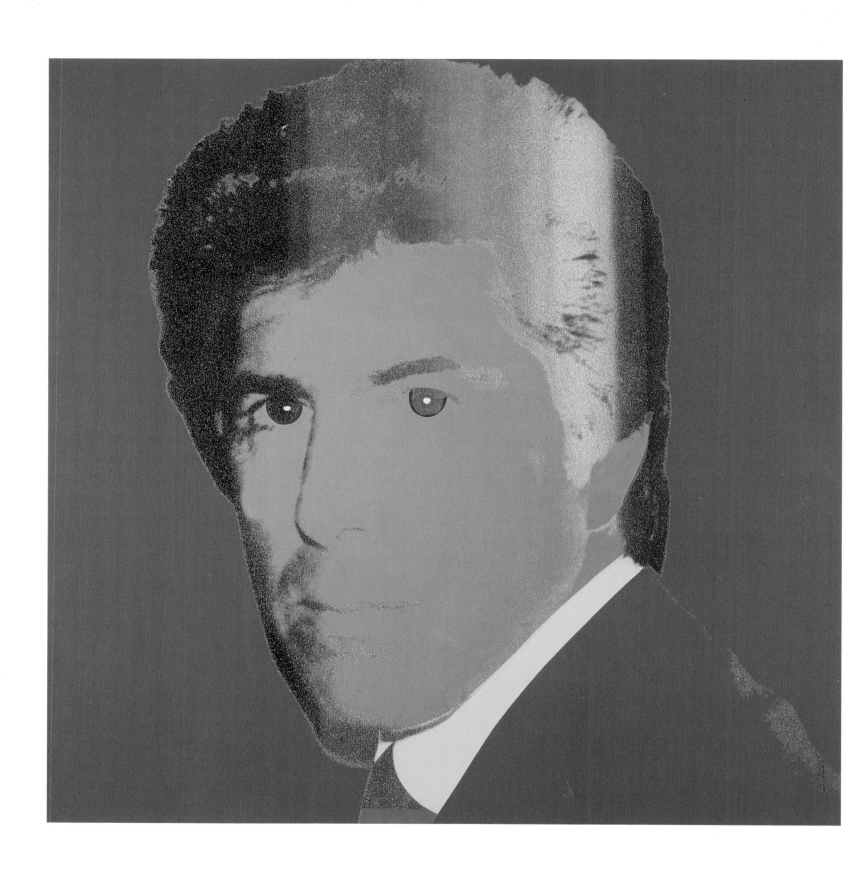

28 STEVE WYNN c.1983

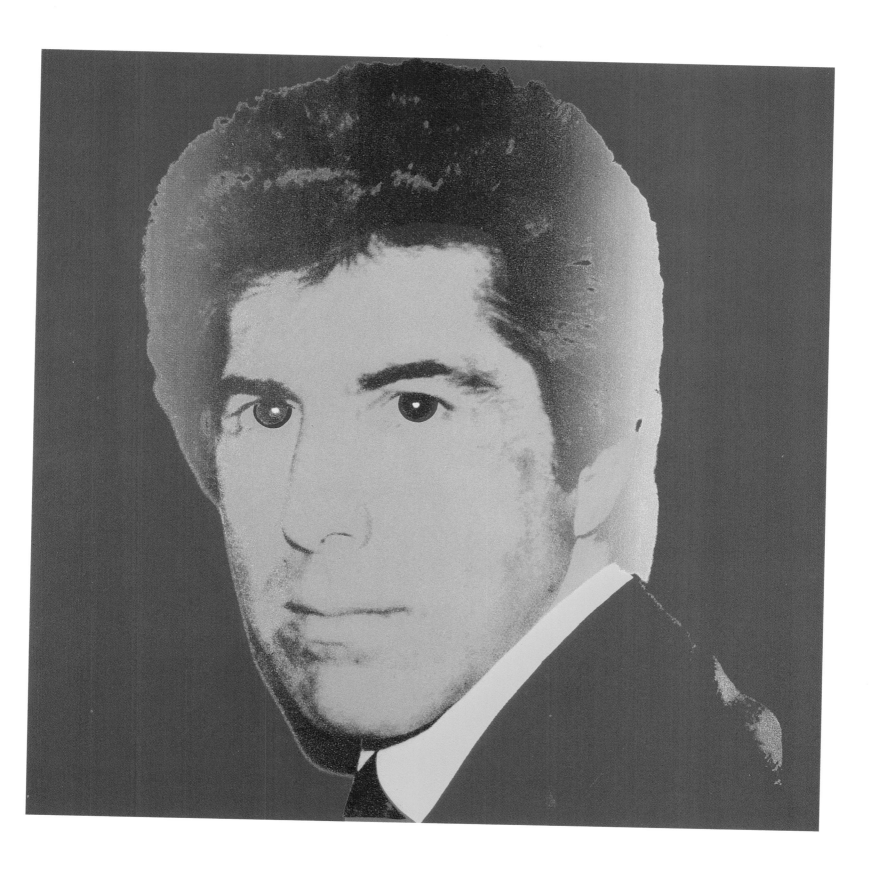

29 STEVE WYNN c.1983

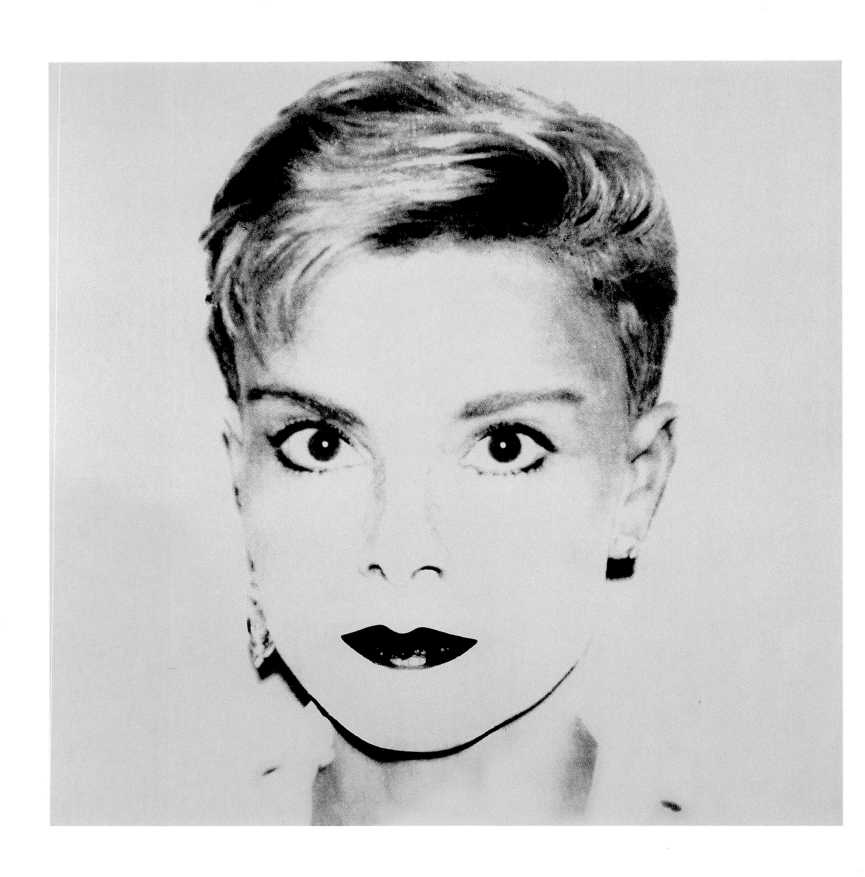

30 BRUNO ACAMPORA, MRS. 1983

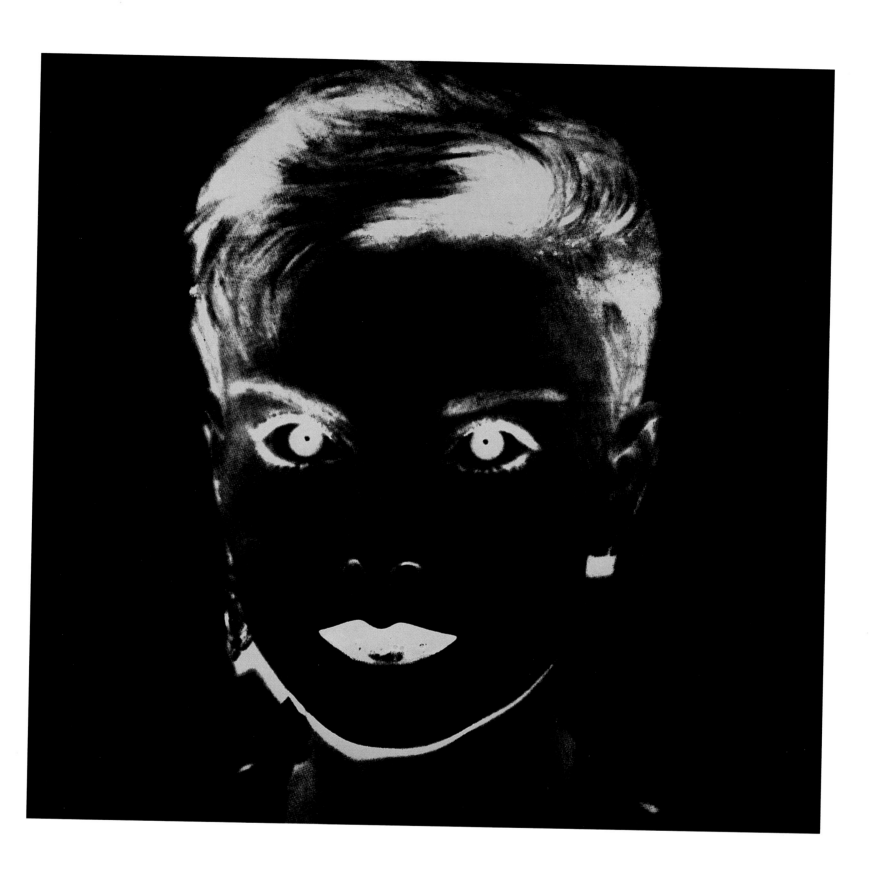

31 BRUNO ACAMPORA, MRS. 1983

32 RYUICHI SAKAMOTO 1984

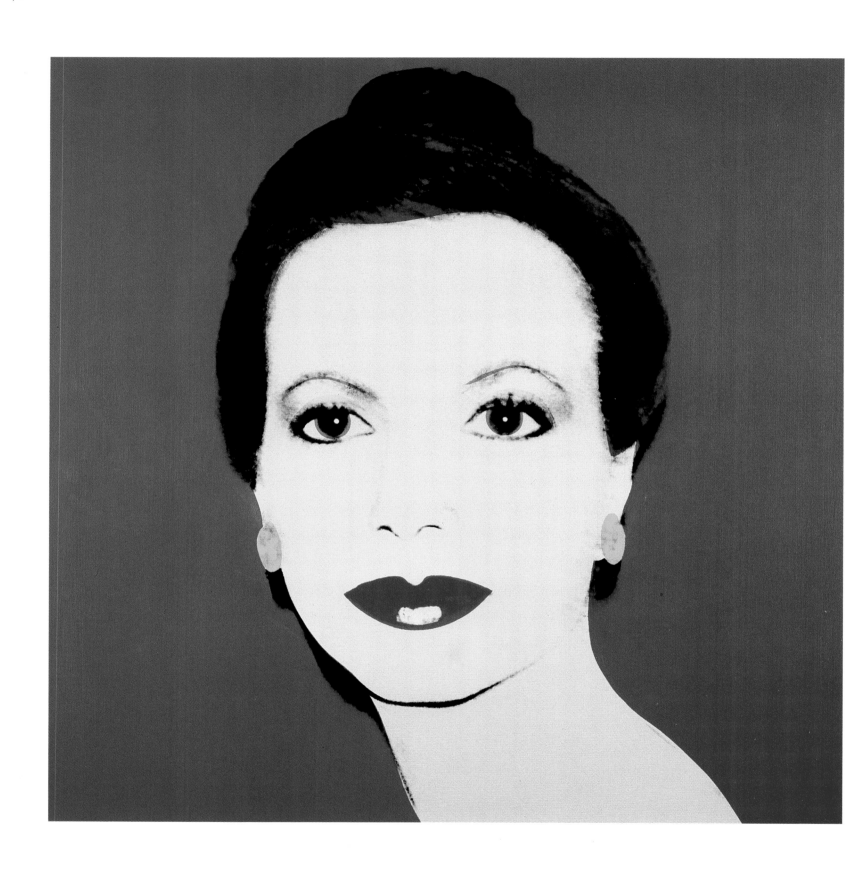

33 CINDY JOHNSON 1984

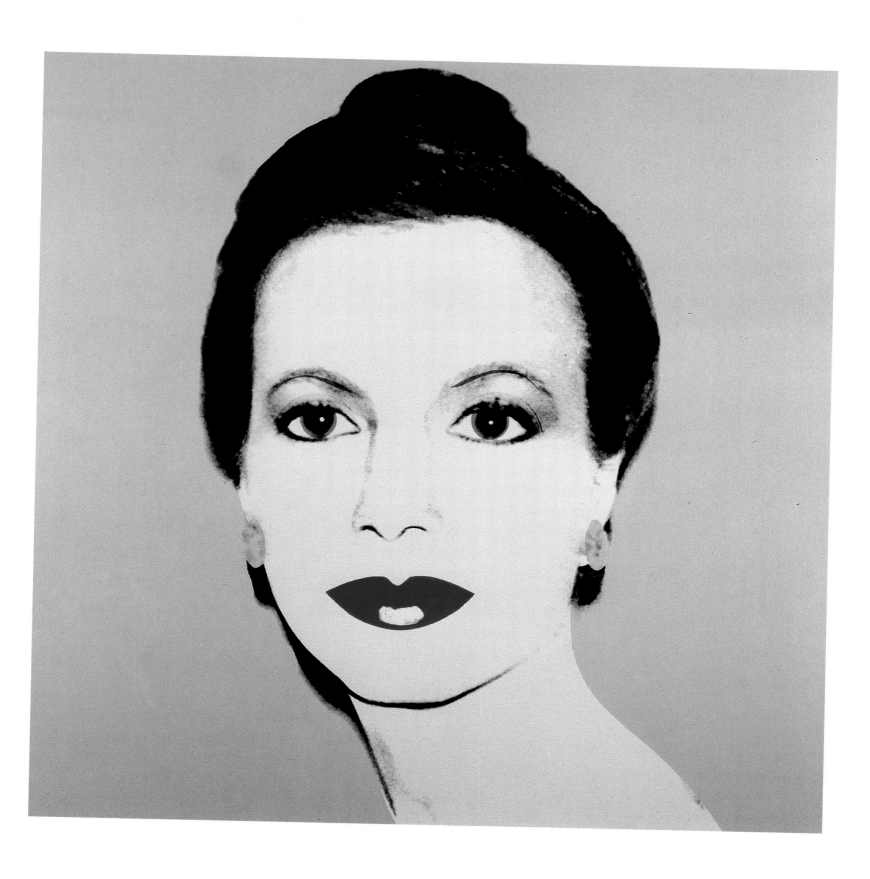

34 CINDY JOHNSON 1984

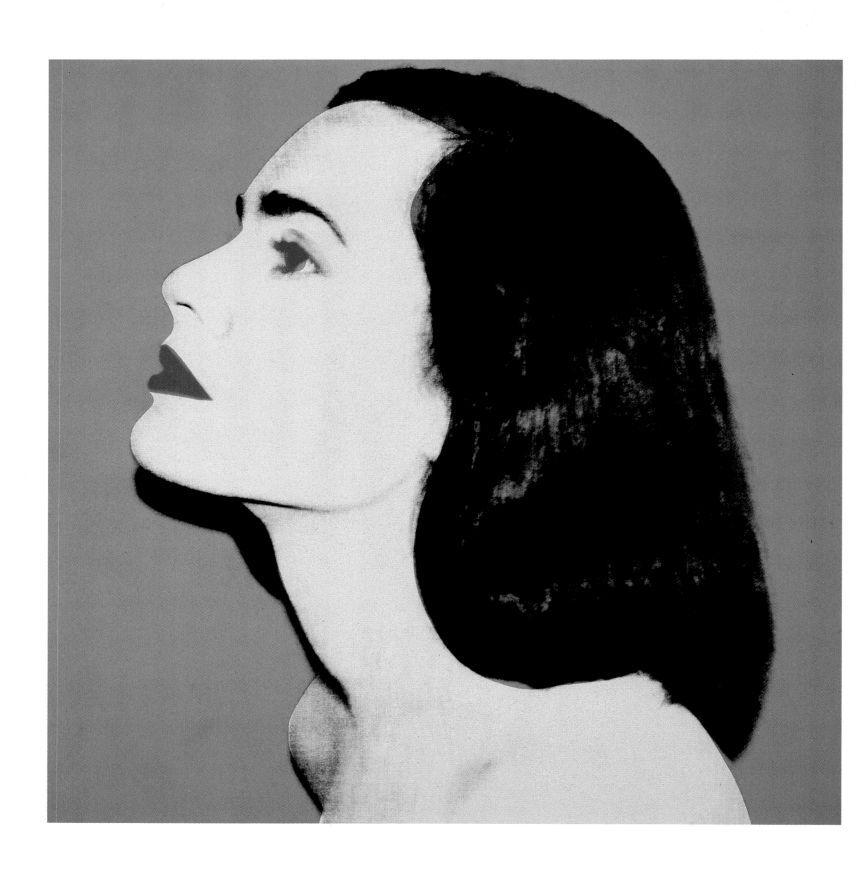

35 PAT HEARN 1985

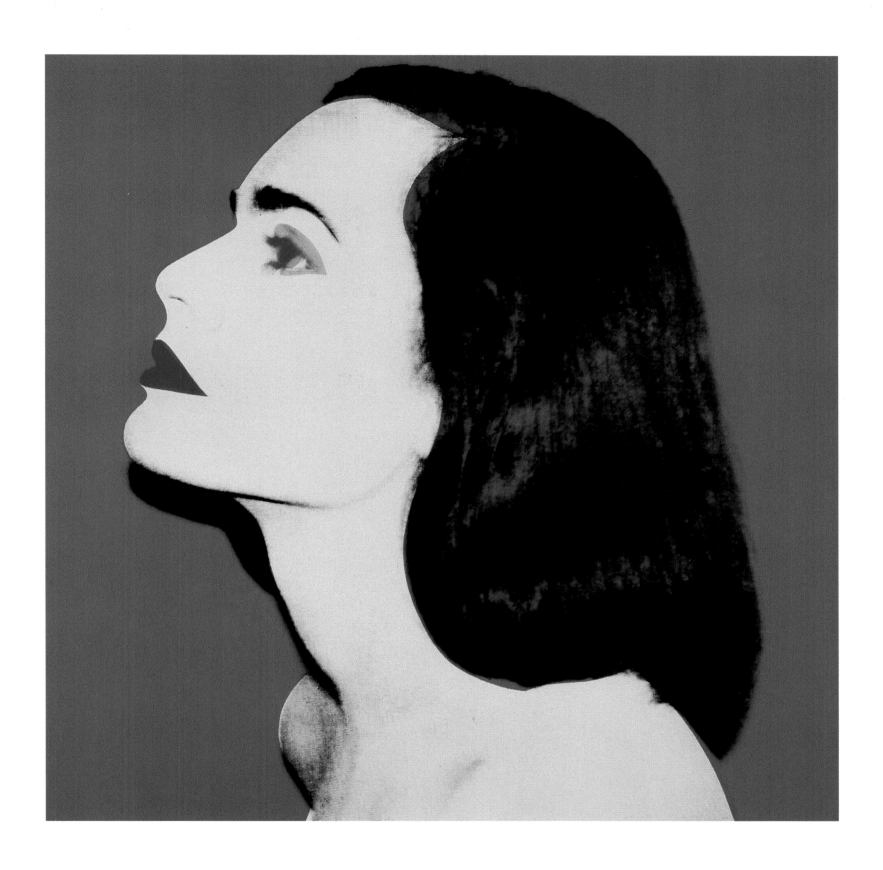

36 PAT HEARN 1985

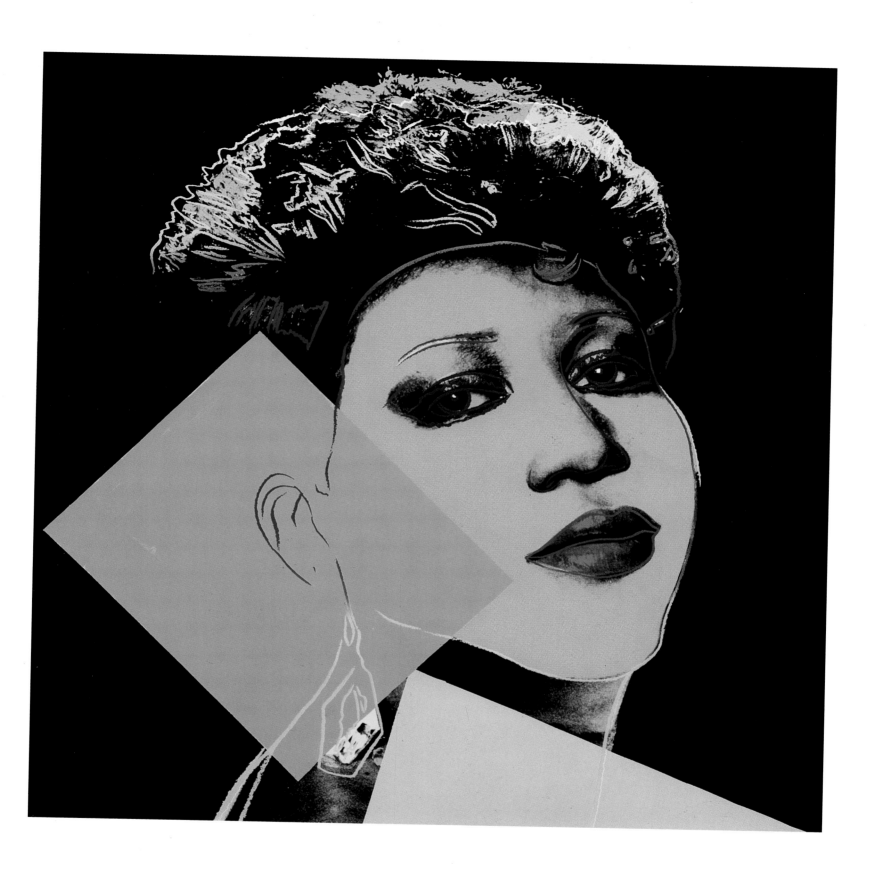

37 ARETHA FRANKLIN c.1986

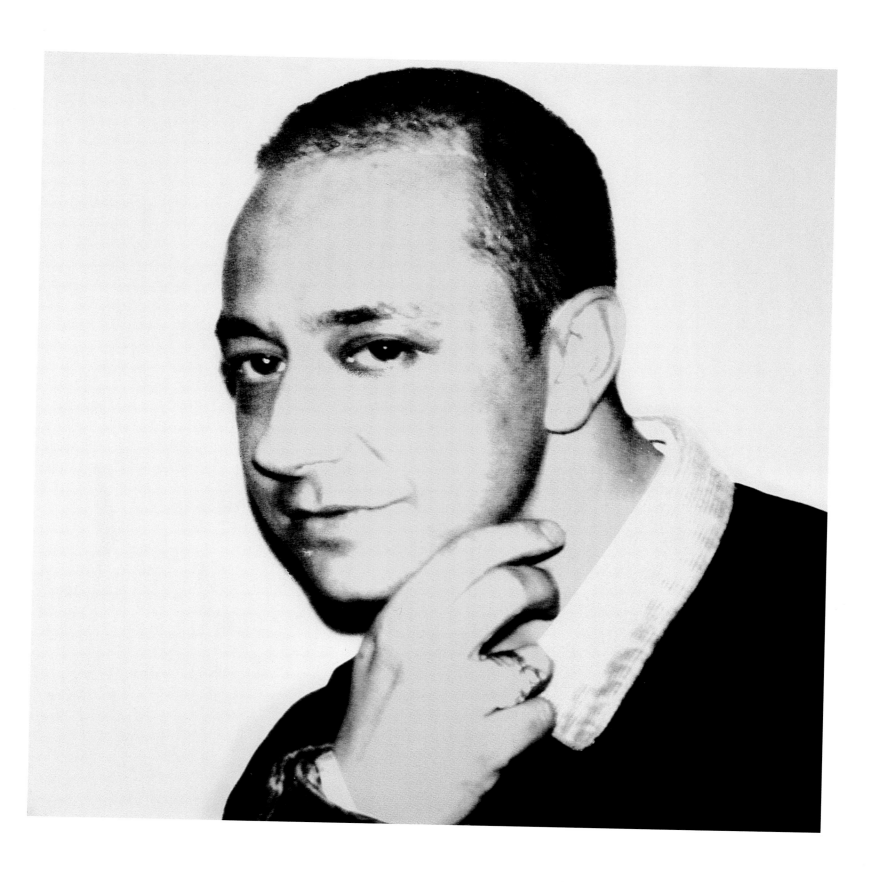

38 ERNESTO ESPOSITO 1986

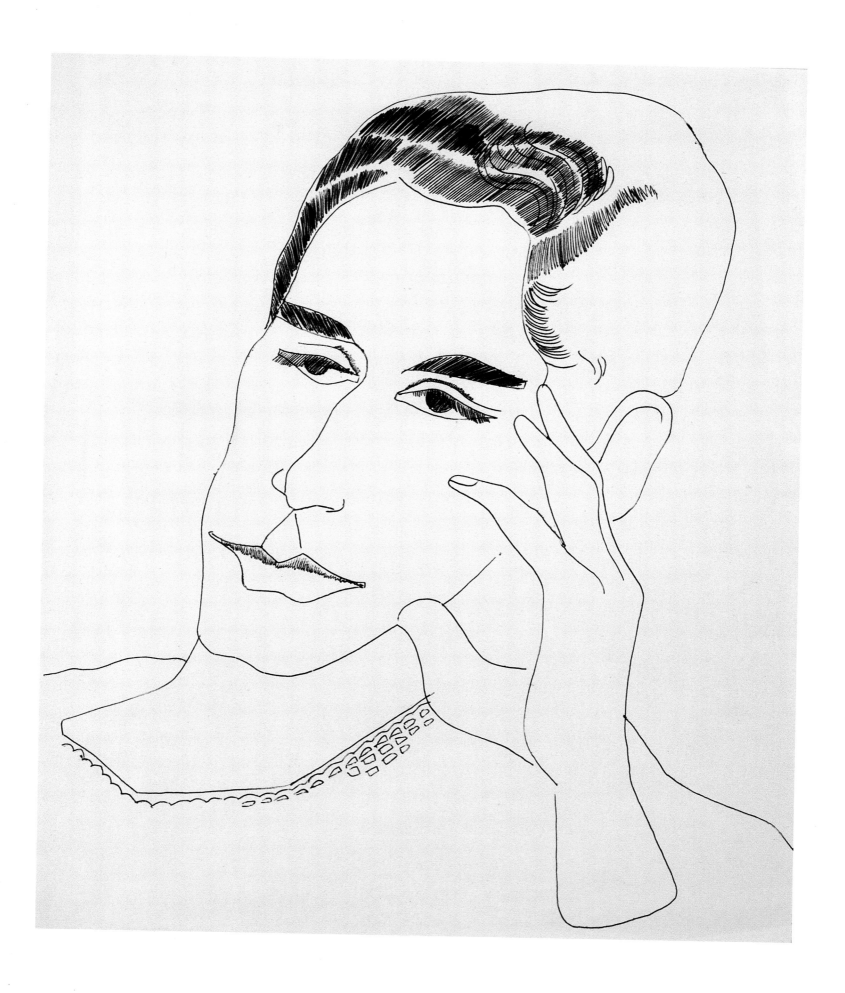

39 UNIDENTIFIED MALE c.1955

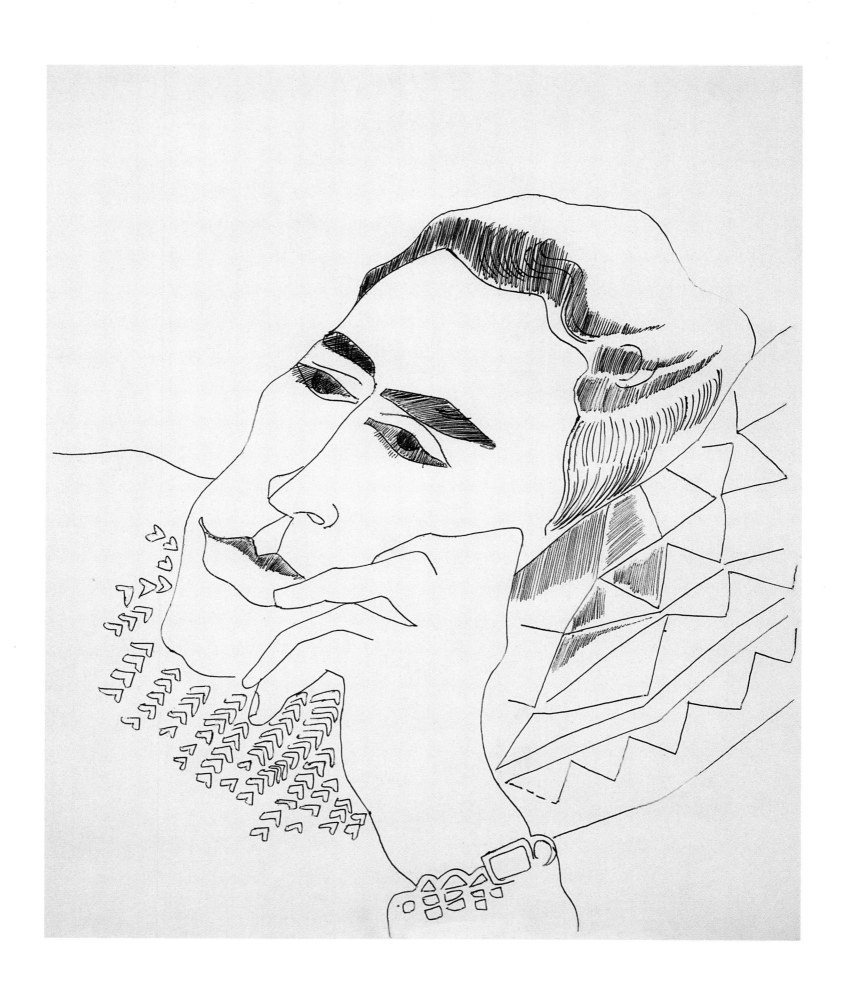

40 UNIDENTIFIED MALE c.1955

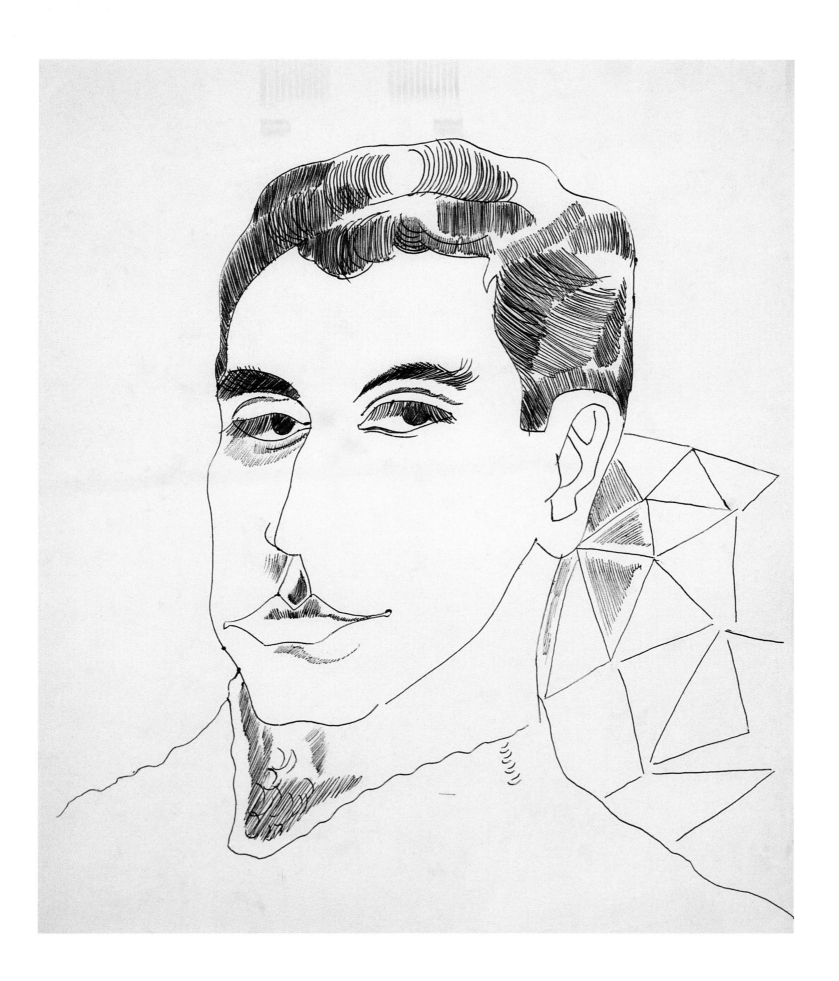

41 UNIDENTIFIED MALE c.1955

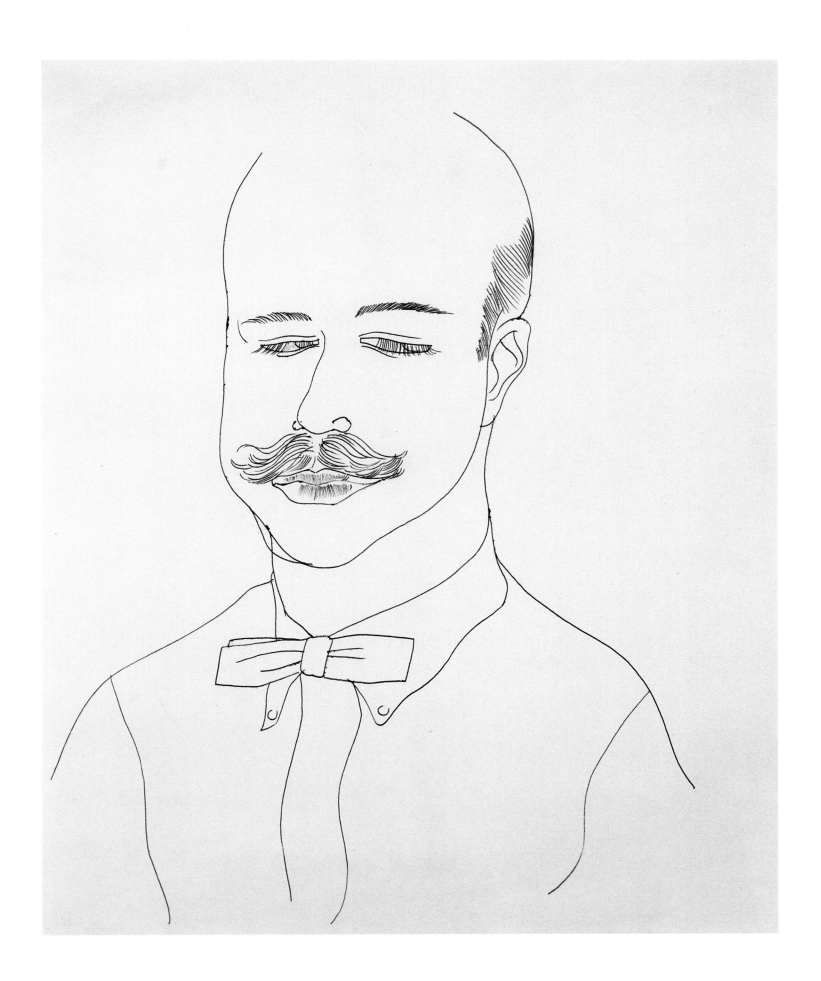

42 UNIDENTIFIED MALE c.1955

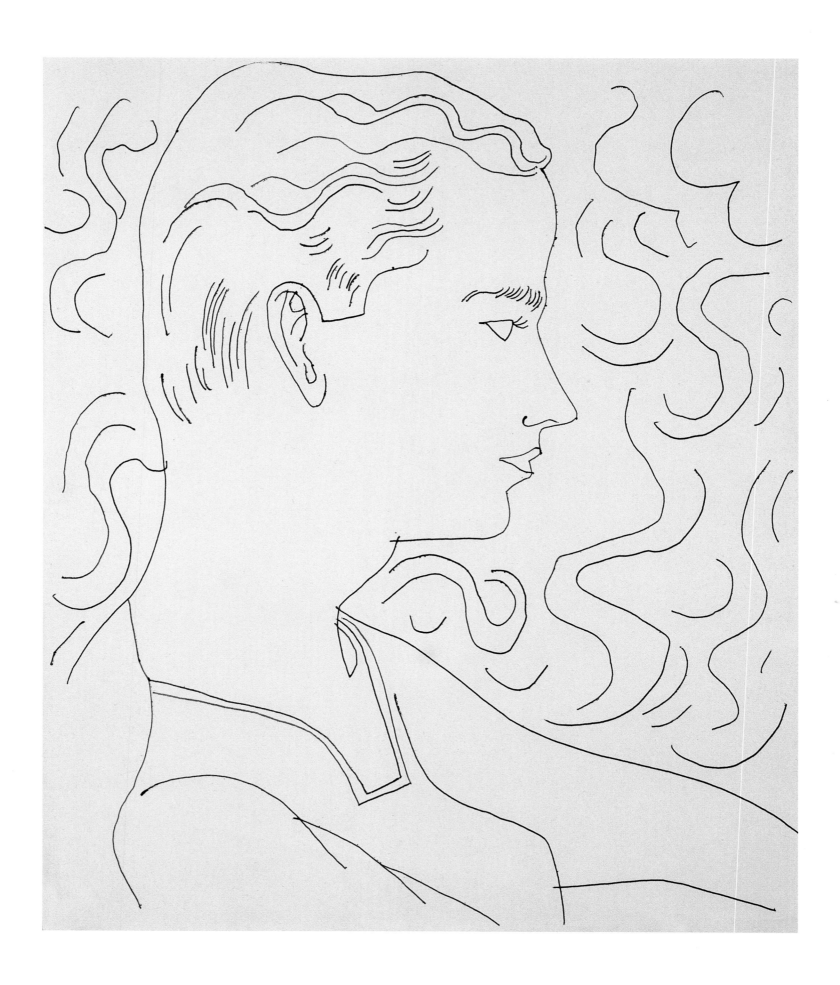

43 UNIDENTIFIED MALE c.1955

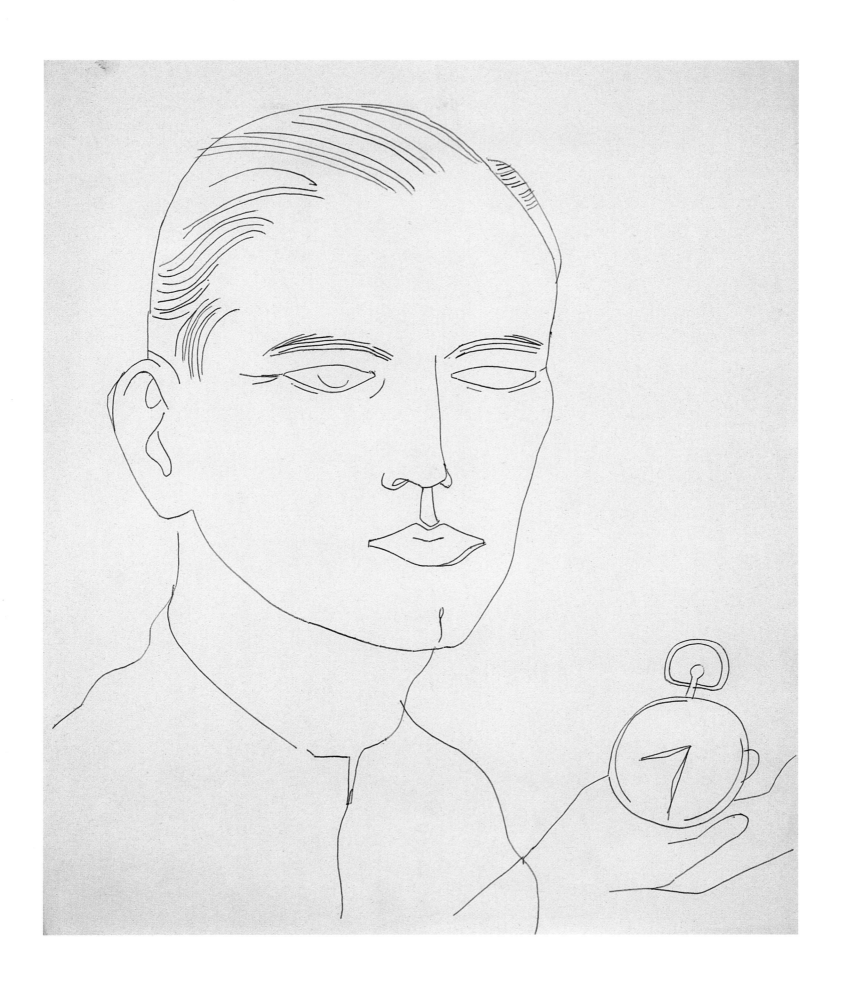

44 UNIDENTIFIED MALE c.1955

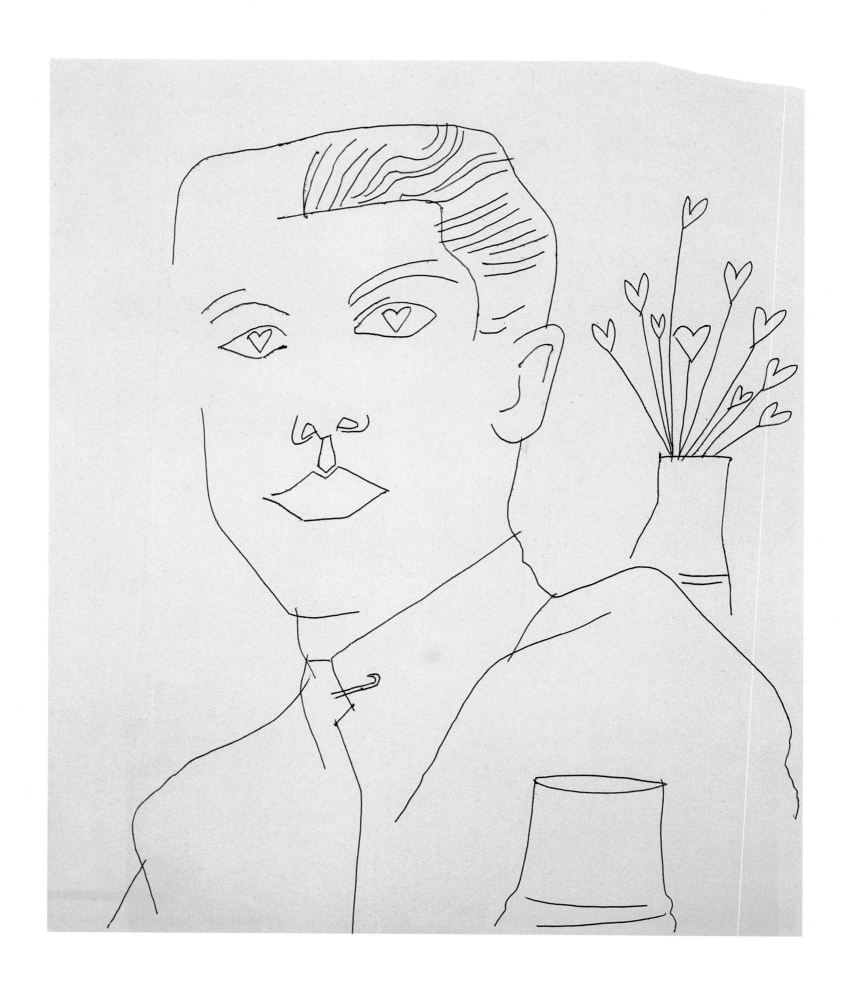

45 UNIDENTIFIED MALE c.1955-57

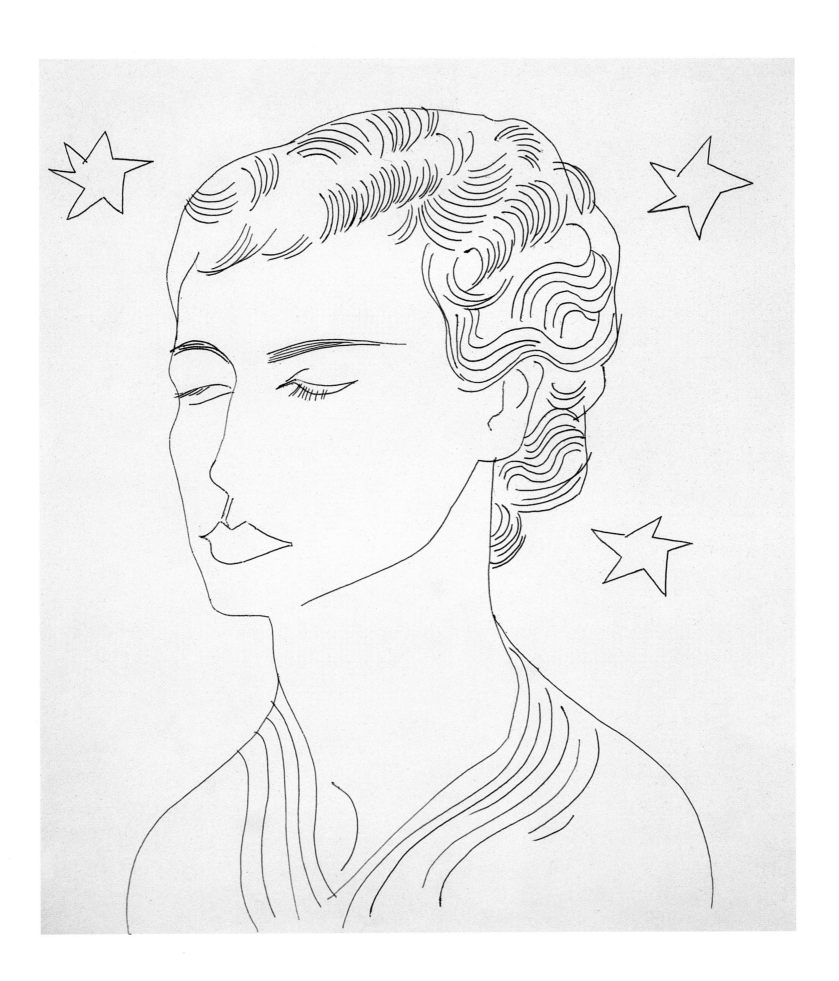

46 UNIDENTIFIED FEMALE c.1955-57

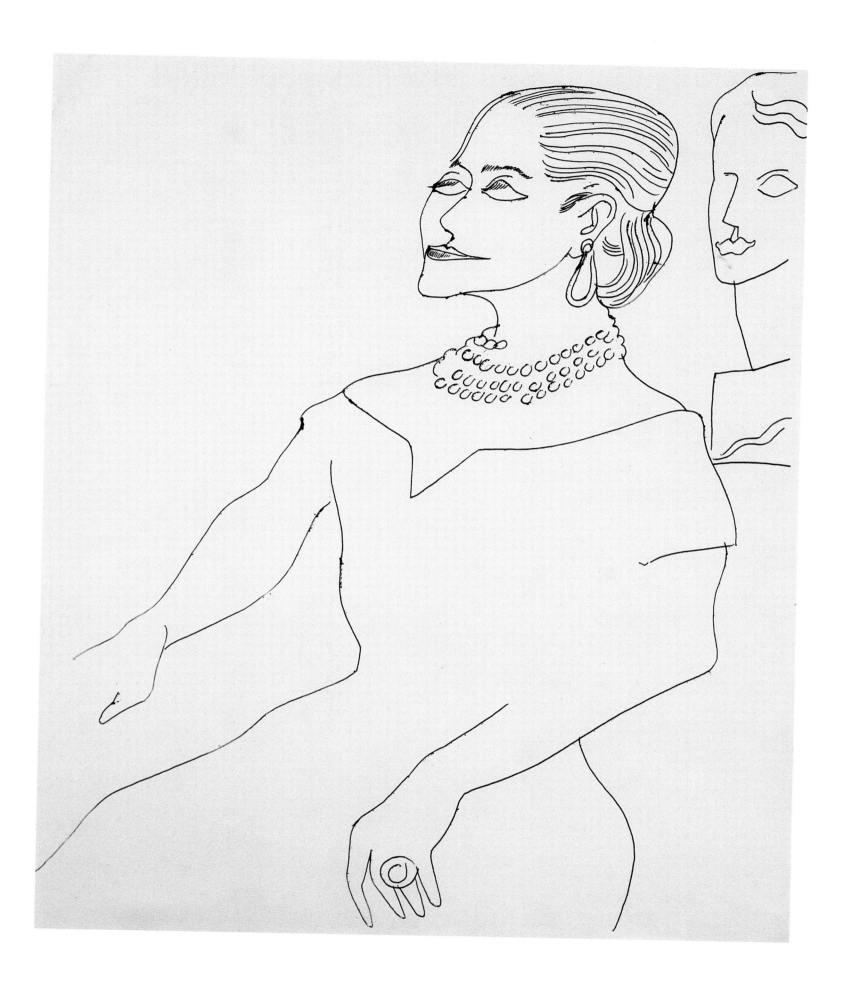

47 HELENA RUBINSTEIN c.1957

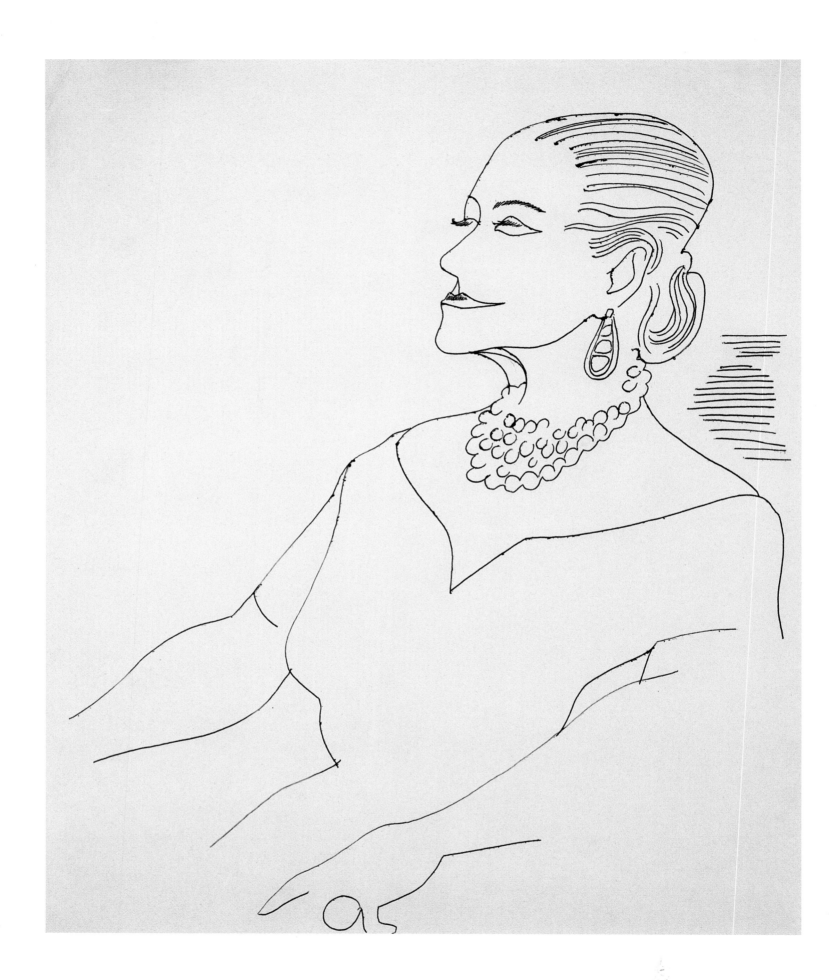

48 HELENA RUBINSTEIN c.1957

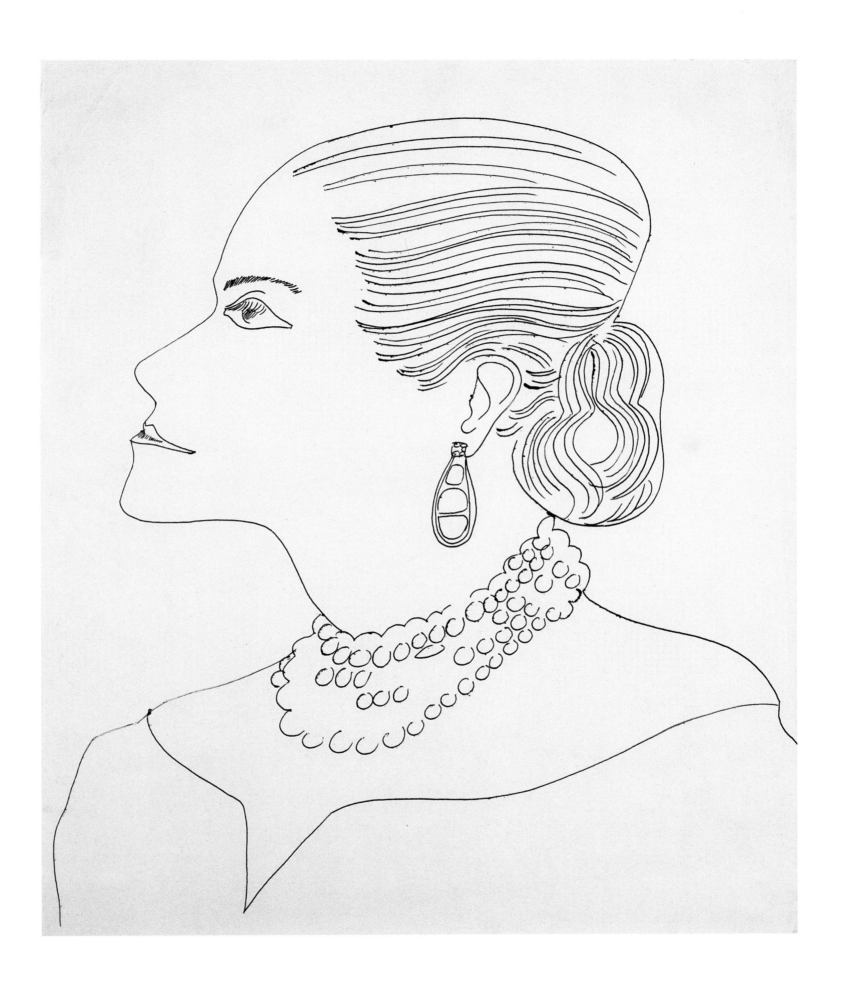

49 HELENA RUBINSTEIN c.1957

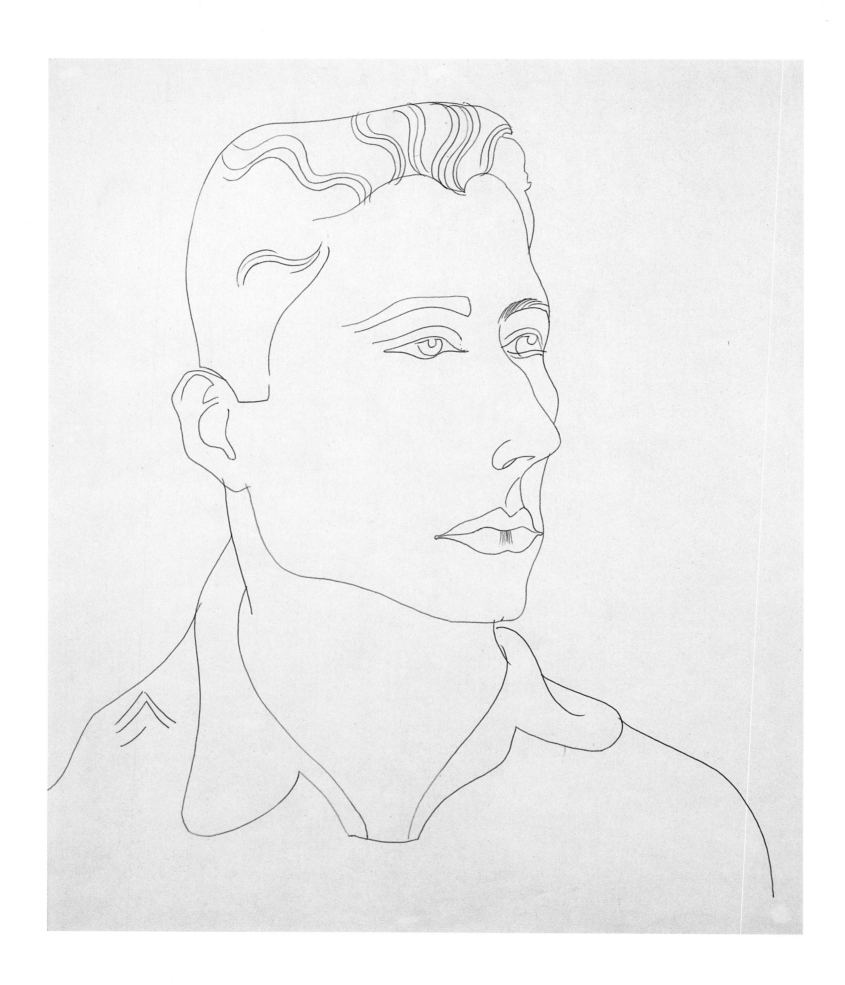

50 UNIDENTIFIED MALE c.1958

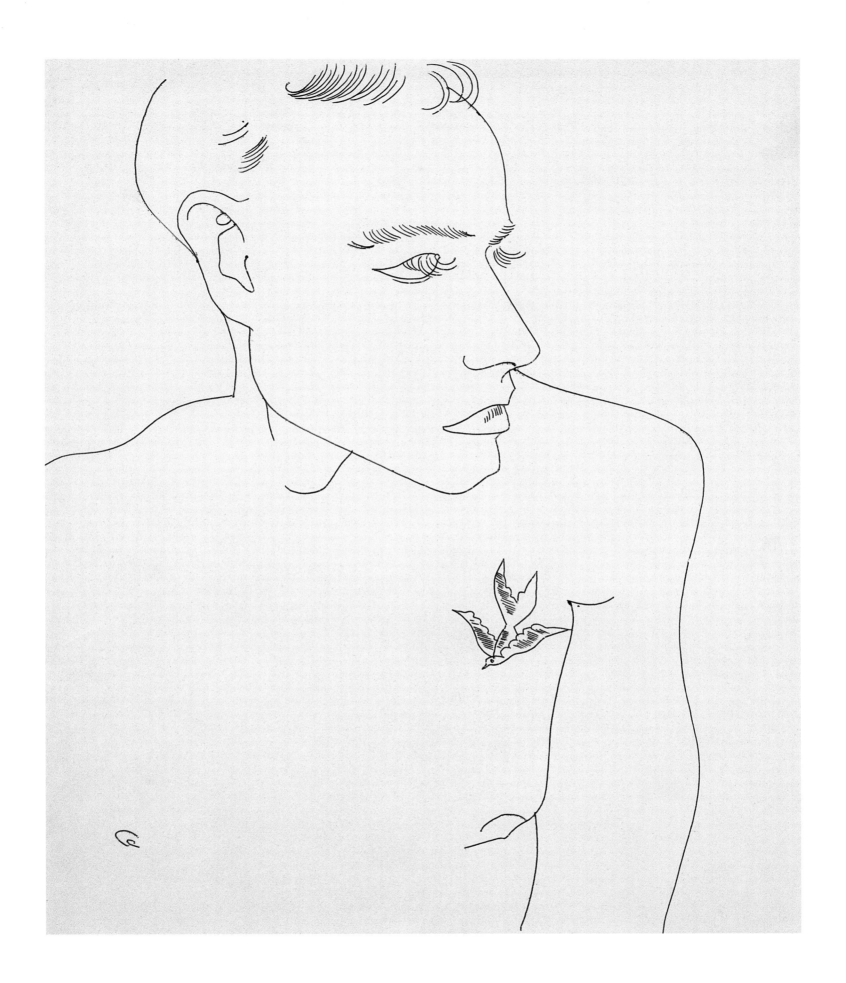

51 UNIDENTIFIED MALE c.1958

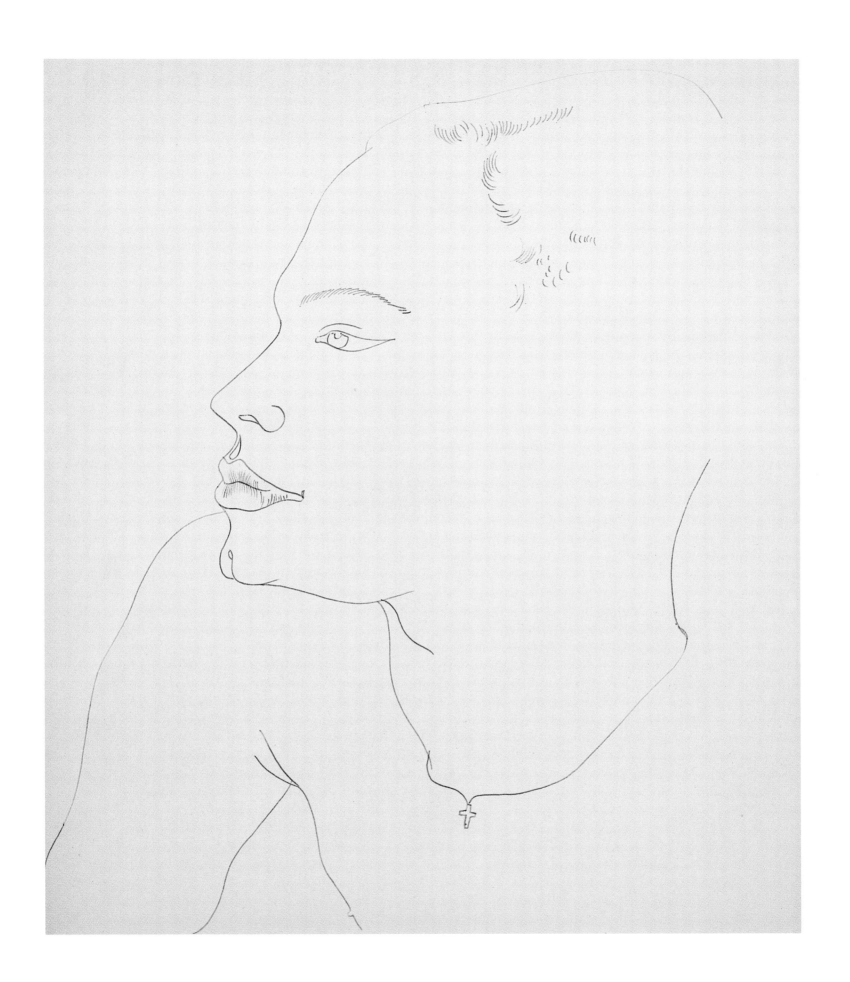

52 UNIDENTIFIED MALE c.1958

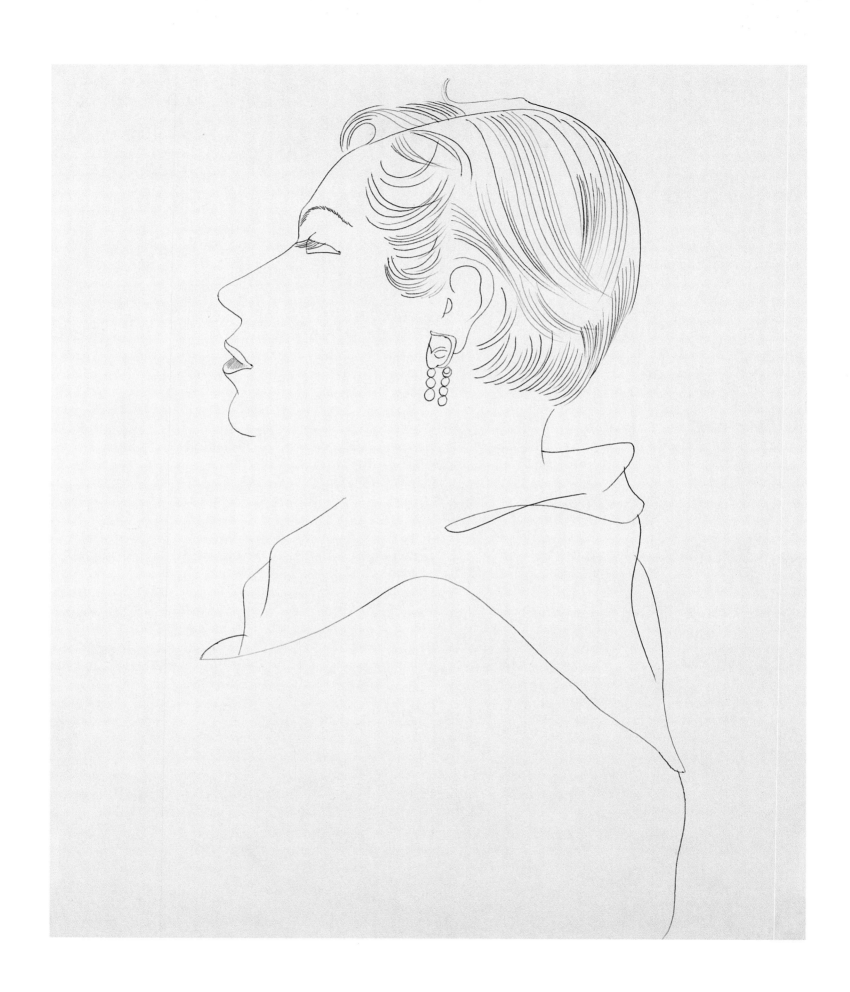

53 UNIDENTIFIED FEMALE c.1960

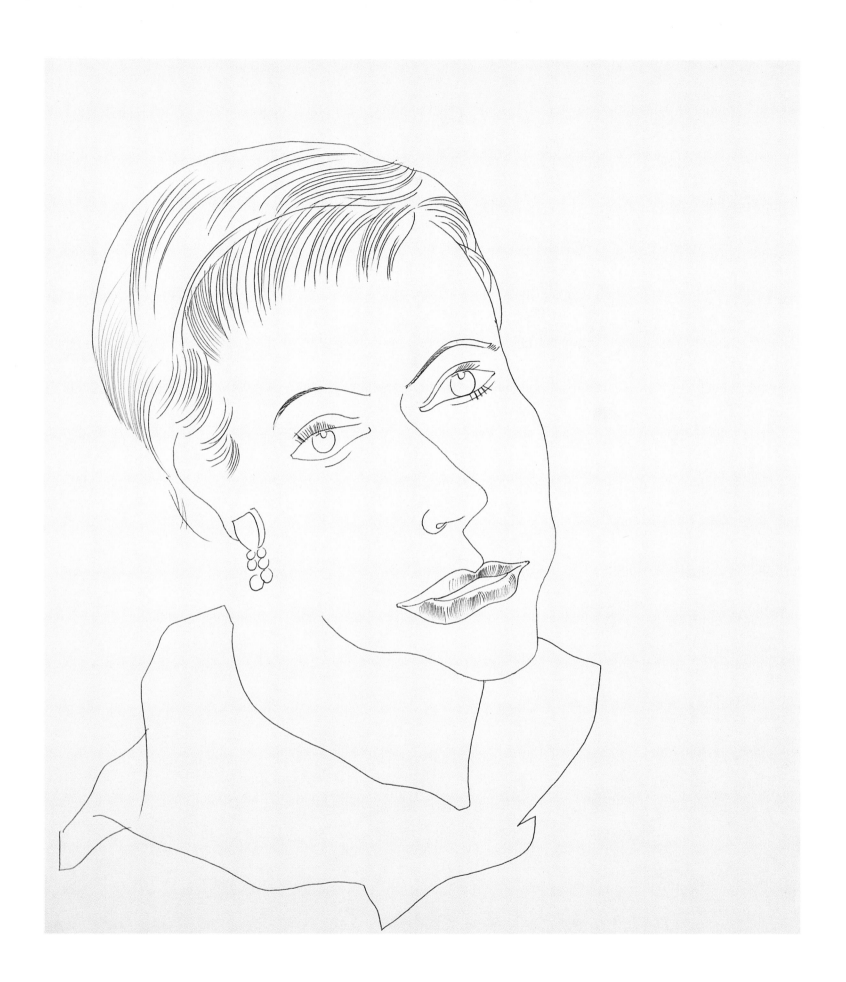

54 UNIDENTIFIED FEMALE c.1960

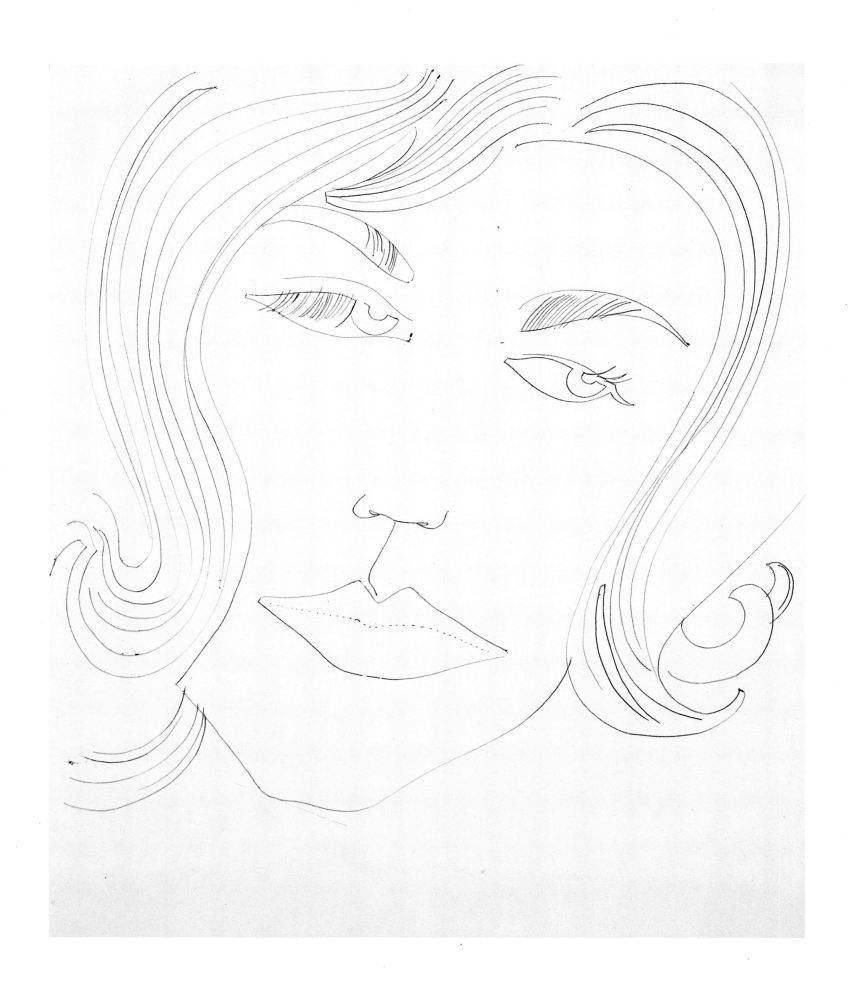

55 UNIDENTIFIED FEMALE c.1960

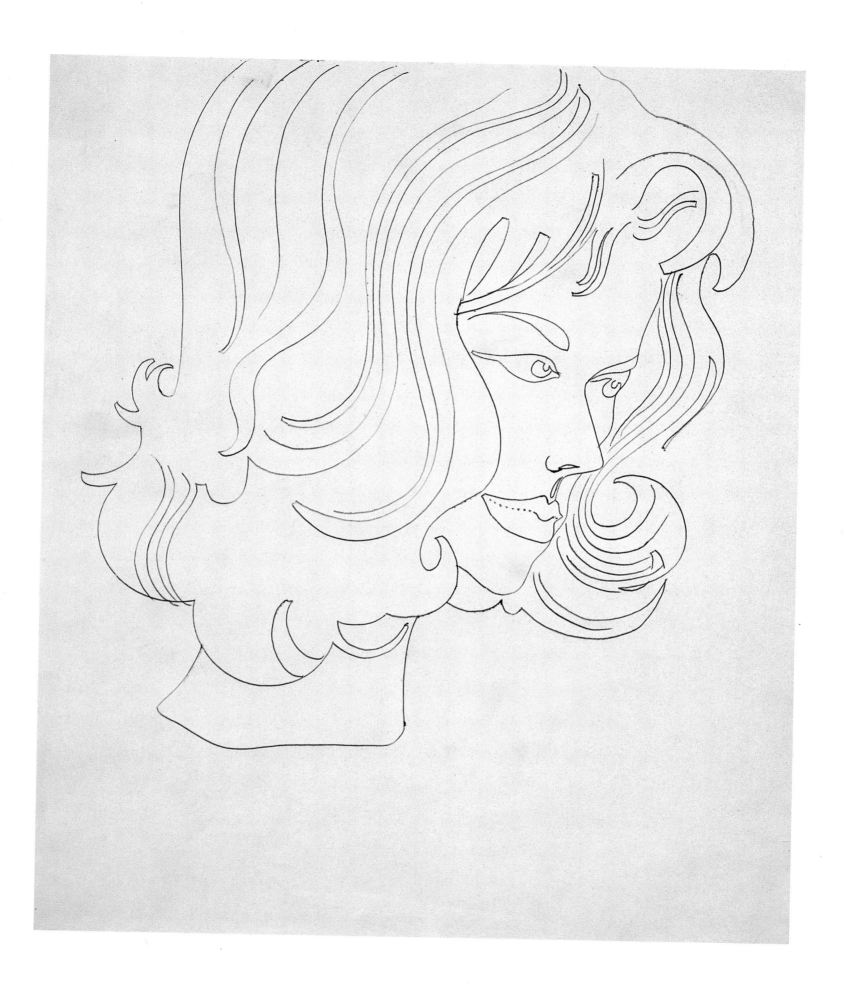

56 UNIDENTIFIED FEMALE c.1960

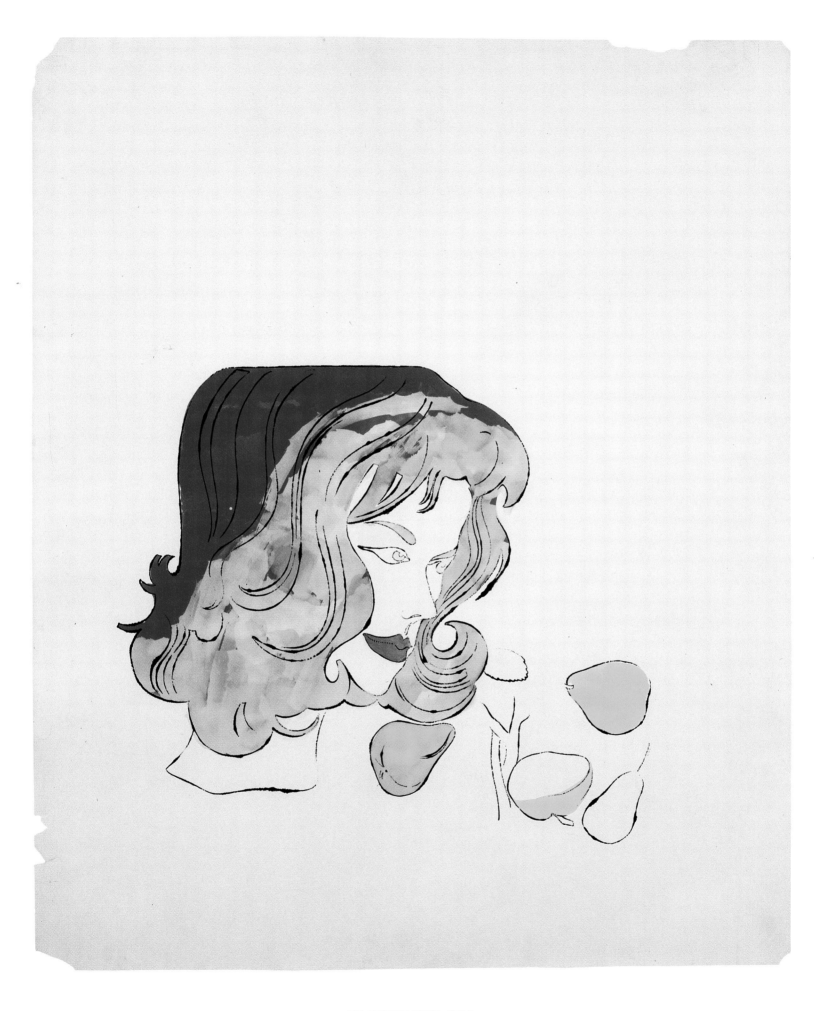

57 FEMALE HEAD 1960

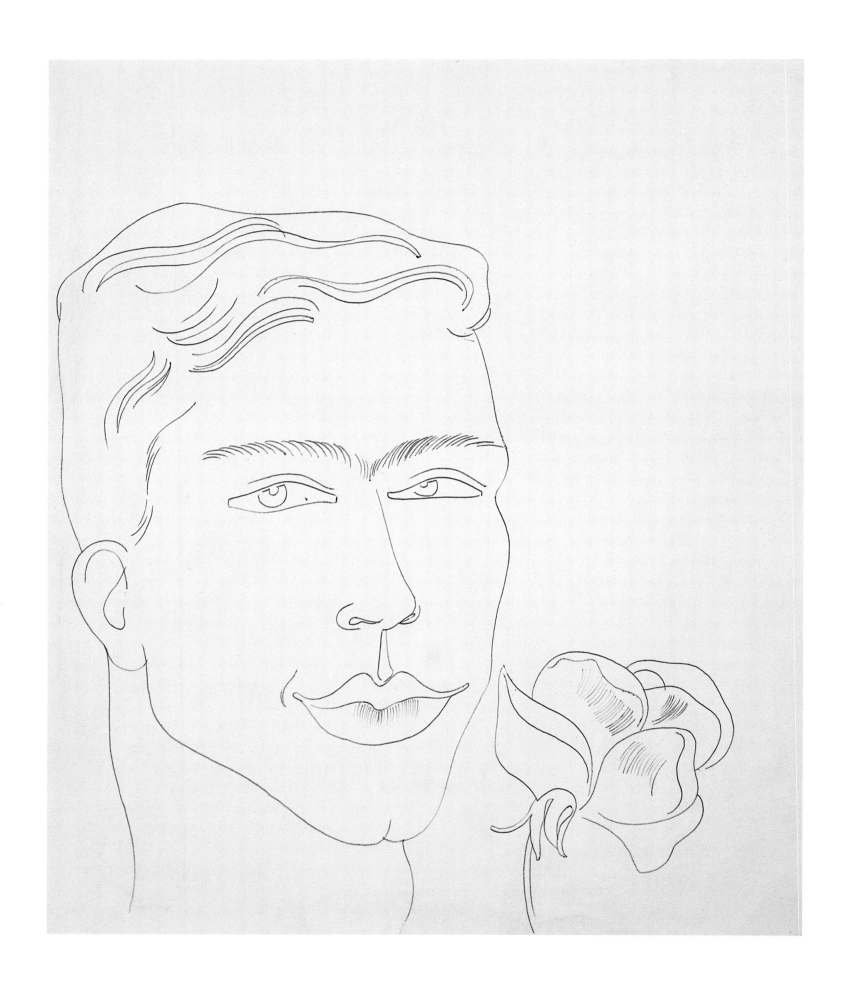

58 UNIDENTIFIED MALE c.1960

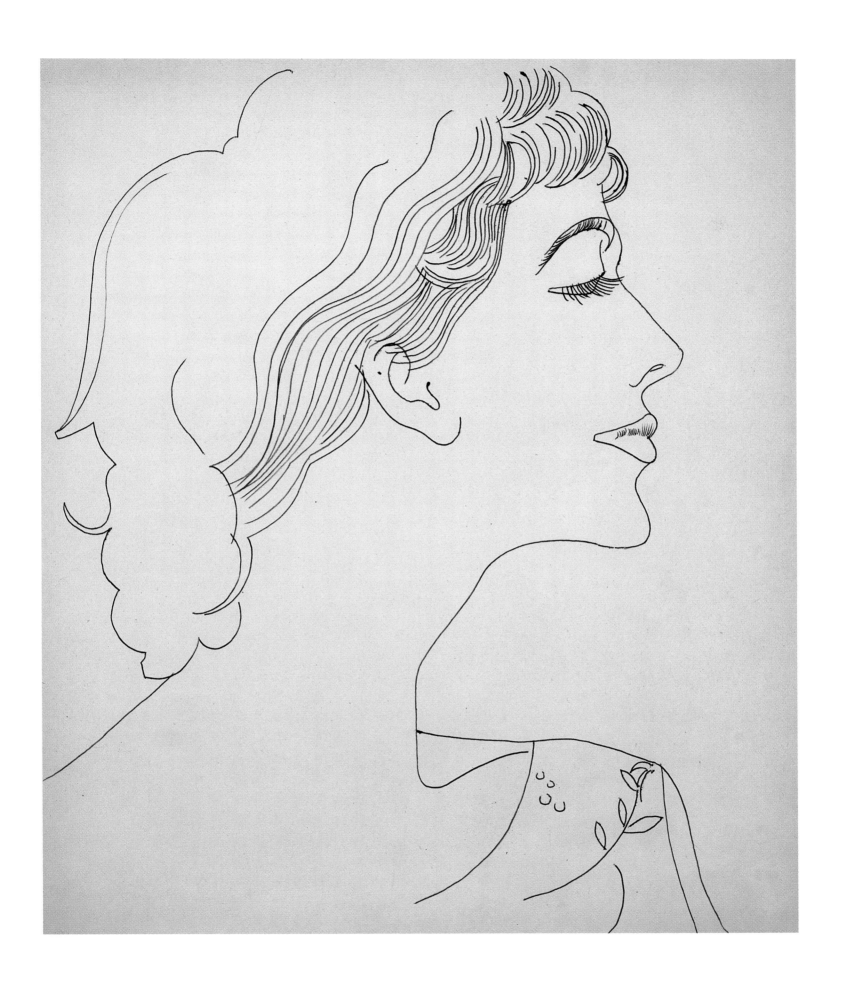

59 UNIDENTIFIED FEMALE c.1960

PAINTINGS

1 Selfportrait, 1986
Synthetic polymer paint
and silkscreen ink on canvas
40 x 40 inches (101,6 x 101,6 cm)

2 Nan Kempner, 1972
Synthetic polymer paint
and silkscreen ink on canvas
40 x 40 inches (101,6 x 101,6 cm)

3 Gianni Agnelli, 1972
Synthetic polymer paint
and silkscreen ink on canvas
40 x 40 inches (101,6 x 101,6 cm)

4 Gianni Agnelli, 1972
Synthetic polymer paint
and silkscreen ink on canvas
40 x 40 inches (101,6 x 101,6 cm)

5 Andre Morgue, 1972
Synthetic polymer paint
and silkscreen ink on canvas
40 x 40 inches (101,6 x 101,6 cm)

6 Andre Morgue, c.1972
Synthetic polymer paint
and silkscreen ink on canvas
40 x 40 inches (101,6 x 101,6 cm)

7 Zimet, Mrs., 1975
Synthetic polymer paint
and silkscreen ink on canvas
40 x 40 inches (101,6 x 101,6 cm)

8 Zimet, Mrs., 1975
Synthetic polymer paint
and silkscreen ink on canvas
40 x 40 inches (101,6 x 101,6 cm)

9 Tina Freeman, 1975
Synthetic polymer paint
and silkscreen ink on canvas
40 x 40 inches (101,6 x 101,6 cm)

10 Tina Freeman, 1975
Synthetic polymer paint
and silkscreen ink on canvas
40 x 40 inches (101,6 x 101,6 cm)

11 Willy Brandt, 1976
Synthetic polymer paint
and silkscreen ink on canvas
40 x 40 inches (101,6 x 101,6 cm)

12 Princess Ashraf Pahlevi (of Iran), 1977
Synthetic polymer paint
and silkscreen ink on canvas
40 x 40 inches (101,6 x 101,6 cm)

13 Princess Ashraf Pahlevi (of Iran), 1977
Synthetic polymer paint
and silkscreen ink on canvas
40 x 40 inches (101,6 x 101,6 cm)

14 Mark Liebowitz, 1977
Synthetic polymer paint
and silkscreen ink on canvas
40 x 40 inches (101,6 x 101,6 cm)

15 Mark Liebowitz, 1977
Synthetic polymer paint
and silkscreen ink on canvas
40 x 40 inches (101,6 x 101,6 cm)

16 Gale Smith, 1978
Synthetic polymer paint
and silkscreen ink on canvas
40 x 40 inches (101,6 x 101,6 cm)

17 Gale Smith, 1978
Synthetic polymer paint
and silkscreen ink on canvas
40 x 40 inches (101,6 x 101,6 cm)

18 Chamberlain, Mr. & Mrs., c.1978
Synthetic polymer paint
and silkscreen ink on canvas
40 x 40 inches (101,6 x 101,6 cm)

19 Chamberlain, Mr. & Mrs., c.1978
Synthetic polymer paint
and silkscreen ink on canvas
40 x 40 inches (101,6 x 101,6 cm)

20 John Reinhold, c.1979
Synthetic polymer paint
and silkscreen ink on canvas
40 x 40 inches (101,6 x 101,6 cm)

21 John Reinhold, c.1979
Synthetic polymer paint
and silkscreen ink on canvas
40 x 40 inches (101,6 x 101,6 cm)

22 Carolina Herrera, 1979
Synthetic polymer paint
and silkscreen ink on canvas
40 x 40 inches (101,6 x 101,6 cm)

23 Jon Gould, 1981
Synthetic polymer paint
and silkscreen ink on canvas
40 x 40 inches (101,6 x 101,6 cm)

24 Jon Gould, 1981
Synthetic polymer paint
and silkscreen ink on canvas
40 x 40 inches (101,6 x 101,6 cm)

25 Anne Bass, 1981
Synthetic polymer paint
and silkscreen ink on canvas
40 x 40 inches (101,6 x 101,6 cm)

26 Julianna Siu, 1982
Synthetic polymer paint
and silkscreen ink on canvas
40 x 40 inches (101,6 x 101,6 cm)

27 Alfred Siu, 1982
Synthetic polymer paint
and silkscreen ink on canvas
40 x 40 inches (101,6 x 101,6 cm)

28 Steve Wynn, c.1983
Synthetic polymer paint, silkscreen ink
and diamond dust on canvas
40 x 40 inches (101,6 x 101,6 cm)

29 Steve Wynn, c.1983
Synthetic polymer paint, silkscreen ink
and diamond dust on canvas
40 x 40 inches (101,6 x 101,6 cm)

30 Bruno Acampora, Mrs., 1983
Synthetic polymer paint
and silkscreen ink on canvas
40 x 40 inches (101,6 x 101,6 cm)

31 Bruno Acampora, Mrs., 1983
Synthetic polymer paint
and silkscreen ink on canvas
40 x 40 inches (101,6 x 101,6 cm)

32 Ryuichi Sakamoto, 1984
Synthetic polymer paint
and silkscreen ink on canvas
40 x 40 inches (101,6 x 101,6 cm)

33 Cindy Johnson, 1984
 Synthetic polymer paint
 and silkscreen ink on canvas
 40 x 40 inches (101,6 x 101,6 cm)

34 Cindy Johnson, 1984
 Synthetic polymer paint
 and silkscreen ink on canvas
 40 x 40 inches (101,6 x 101,6 cm)

35 Pat Hearn, 1985
 Synthetic polymer paint
 and silkscreen ink on canvas
 40 x 40 inches (101,6 x 101,6 cm)

36 Pat Hearn, 1985
 Synthetic polymer paint
 and silkscreen ink on canvas
 40 x 40 inches (101,6 x 101,6 cm)

37 Aretha Franklin, c. 1986
 Synthetic polymer paint
 and silkscreen ink on canvas
 40 x 40 inches (101,6 x 101,6 cm)

38 Ernesto Esposito, 1986
 Synthetic polymer paint
 and silkscreen ink on canvas
 40 x 40 inches (101,6 x 101,6 cm)

DRAWINGS

39 Unidentified Male, c.1955
 Black ballpoint on manila paper
 16 3/4 x 13 7/8 inches
 (42,6 x 35,2 cm)

40 Unidentified Male, c.1955
 Black ballpoint on manila paper
 16 3/4 x 13 7/8 inches)
 (42,6 x 35,2 cm)

41 Unidentified Male, c.1955
 Black ballpoint on manila paper
 16 3/4 x 13 7/8 inches
 (42,6 x 35,2 cm)

42 Unidentified Male, c.1955
 Black ballpoint on manila paper
 16 7/8 x 13 3/4 inches
 (42,9 x 34,9 cm)

43 Unidentified Male, c.1955
 Black ballpoint on manila paper
 16 7/8 x 14 inches
 (42,9 x 35,6 cm)

44 Unidentified Male, c.1955
 Black ballpoint on manila paper
 16 7/8 x 14 inches
 (42,9 x 35,6 cm)

45 Unidentified Male, c.1955-57
 Black ballpoint on manila paper
 16 3/4 x 13 7/8 inches
 (42,6 x 35,2 cm)

46 Unidentified Female, c.1955-57
 Black ballpoint on manila paper
 16 3/4 x 13 7/8 inches
 (42,6 x 35,2 cm)

47 Helena Rubinstein, c.1957
 Black ballpoint on manila paper
 16 7/8 x 13 3/4 inches
 (42,9 x 34,9 cm)

48 Helena Rubinstein, c.1957
 Black ballpoint on manila paper
 16 7/8 x 13 3/4 inches
 (42,9 x 34,9 cm)

49 Helena Rubinstein, c.1957
 Black ballpoint on manila paper
 16 7/8 x 13 3/4 inches
 (42,9 x 34,9 cm)

50 Unidentified Male, c.1958
 Blue ballpoint on manila paper
 16 7/8 x 13 7/8 inches
 (42,9 x 35,2 cm)

51 Unidentified Male, c.1958
 Black ballpoint on ivory paper
 17 1/8 x 14 inches
 (43,5 x 35,6 cm)

52 Unidentified Male, c.1958
 Black ballpoint on tan paper
 16 7/8 x 13 7/8 inches
 (42,9 x 35,2 cm)

53 Unidentified Female, c.1960
 Black ballpoint on white paper
 17 1/8 x 14 inches
 (43,5 x 35,6 cm)

54 Unidentified Female, c.1960
 Black ballpoint on white paper
 17 1/8 x 14 inches
 (43,5 x 35,6 cm)

55 Unidentified Female, c.1960
 Black ballpoint on manila paper
 16 3/4 x 13 7/8 inches
 (42,6 x 35,2 cm)

56 Unidentified Female, c.1960
 Black ballpoint on manila paper
 16 5/8 x 13 7/8 inches
 (42,2 x 35,2 cm)

57 Female Head, 1960
 Ink and Dr. Martin's Aniline Dye
 on Strathmore Seconds paper
 28 5/8 x 22 5/8 inches (70,7 x 57,5 cm)

58 Unidentified Male, c.1960
 Black ballpoint on manila paper
 16 3/4 x 13 7/8 inches
 (42,6 x 35,2 cm)

59 Unidentified Female, c.1960
 Black ballpoint on tan paper
 16 3/4 x 13 7/8 inches
 (42,6 x 35,2)

Special thanks to Vincent Fremont
and Beth Savage, Scott Ferguson,
Matt Miller, Michael Hermann

This book has been published
on the occasion of the exhibition
ANDY WARHOL
'HEADSHOTS' PORTRAITS
DRAWINGS OF THE 50'S
PAINTINGS OF THE 70'S AND 80'S
at Jablonka Galerie, May 5 – June 24, 2000
Lindenstraße 19, D-50674 Köln
Telefon (49) 221-24034 26, Fax 2408132

Publisher
Rafael Jablonka

Editor
Kay Heymer

Typography
Kühle und Mozer, Köln

Printing
Snoeck Ducaju & Zoon, Gent

Distribution Europe
Buchhandlung Walther König, Köln

Distribution rest of the world
D.A.P./Distrituted Art Publishers, New York

ISBN 3-931354-14-8

Printed and bound in Belgium